Contents

Introduction

Wool embroidery is a leisurely hobby that requires only some fabric, wool, and a needle. Your embroidery's fluffy warm finish will be pleasing to the eye—even if it is not perfectly stitched—and will give a tender impression not found with cotton or hemp thread.

This book describes the use of small balls of embroidery wool and ultrafine wool, which are strong enough to be used for sewing machines. It also introduces various types of embroidery techniques, such as free embroidery, cross-stitch, stumpwork, crewelwork, canvas work, and more. You can do embroidery on a ready-made handbag, stole, book jacket, felt slippers, and other simple articles to enhance their attractiveness.

It's also fun to ponder on what motif to choose from the full-scale designs illustrated in this book while thinking about your next embroidery project. During the cold season, why don't you make fancy small articles using fluffy wool?

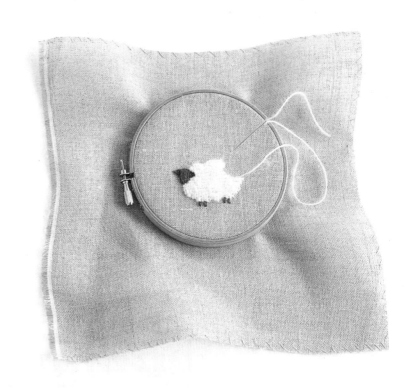

● **Sheep Motif**
See page 63 for pattern instructions.

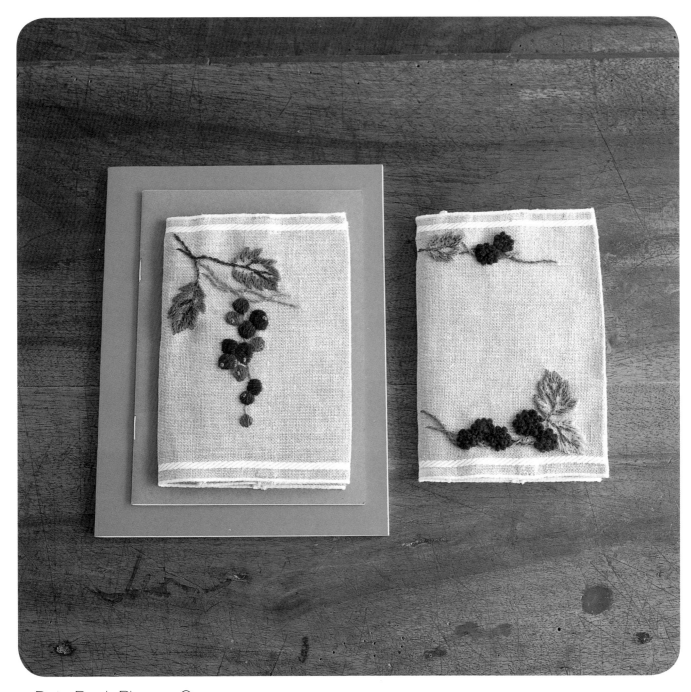

Date Book Planner Cover

This pocketbook-sized cover can be used as a book jacket. The berry design
is stitched in 3-D with French knots.

See page 46 for
pattern instructions.

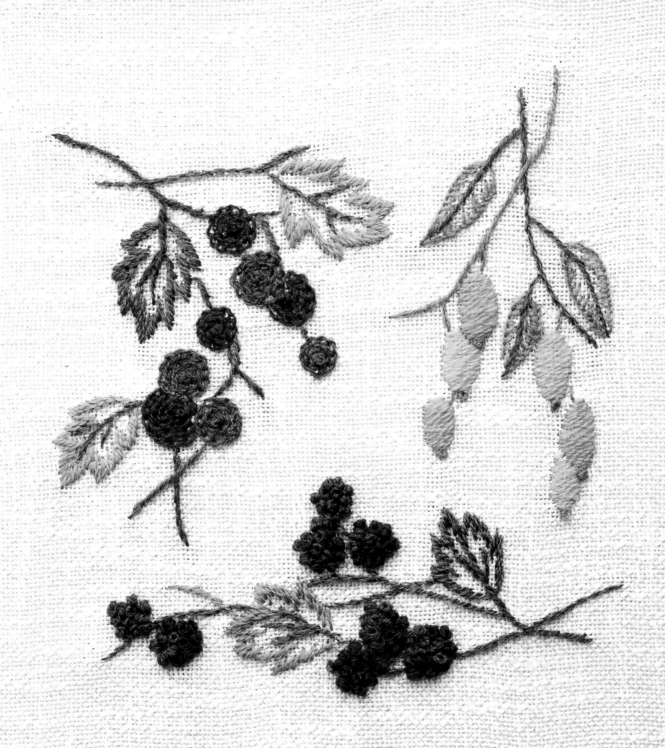

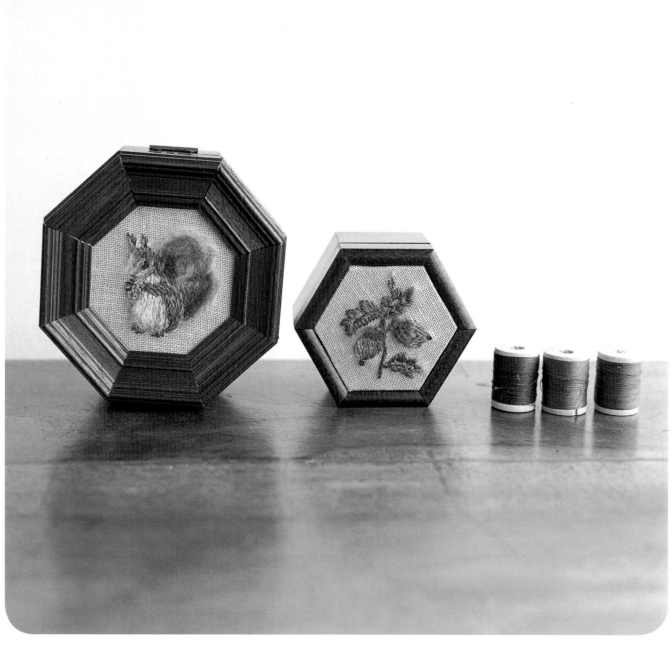

⬢ Accessory Boxes

The accessory box on the left shows an embroidery design of a cute squirrel with fluffy fur. After embroidering the squirrel with thin wool, tease it up with a brush. Make another box with little acorns for your squirrel.

See page 48 for
pattern instructions.

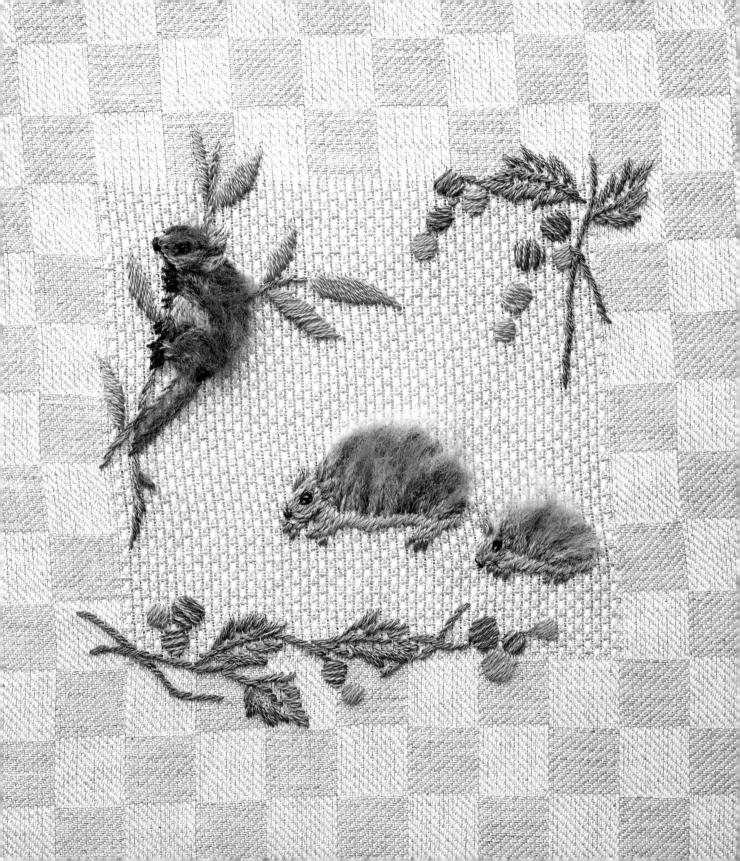

Bag and Purse

The designs on these bags are cross-stitched on fleece using
waste canvas. The handmade work is easy to do on a weekend.

See page 50 for
pattern instructions.

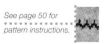

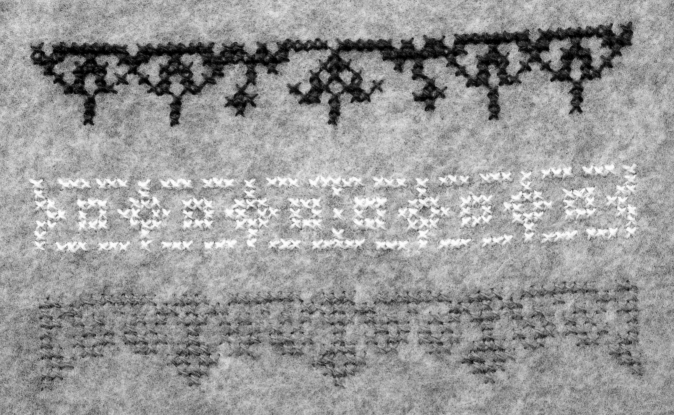
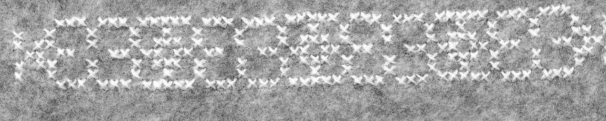

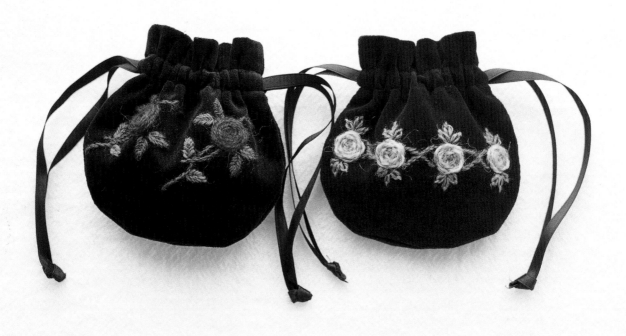

⬤ Mini Purse

This purse is perfect for storing accessories and small items. The rose flower patterns are called spiderweb roses, and are embroidered by weaving the thread in circles like a spider's web.

See page 52 for pattern instructions.

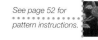

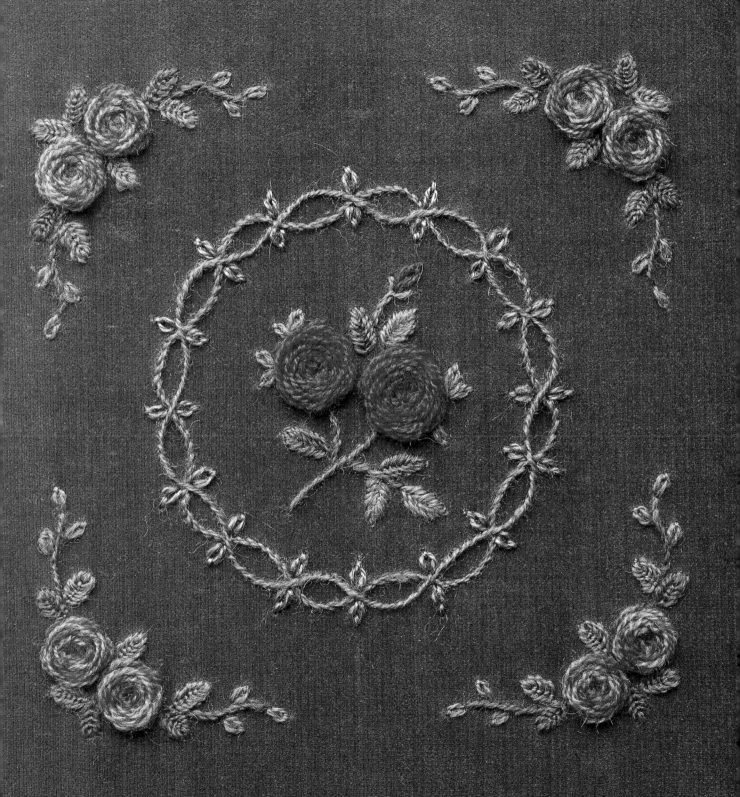

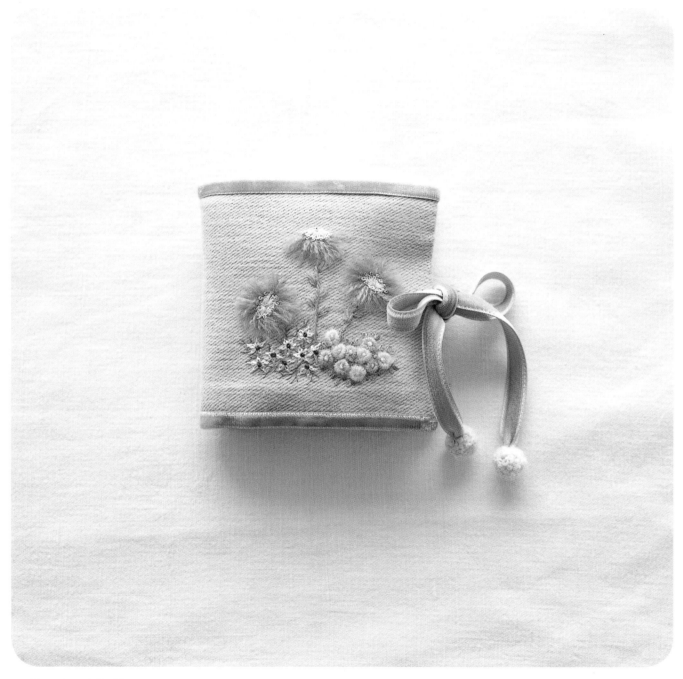

Sewing Kit Case

Would you like to make a convenient sewing kit case that is easy to carry around? When you open the flap, you will find a scissors case and a detachable pincushion. This cute case should make embroidering so much fun.

See page 55 for
pattern instructions.

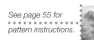

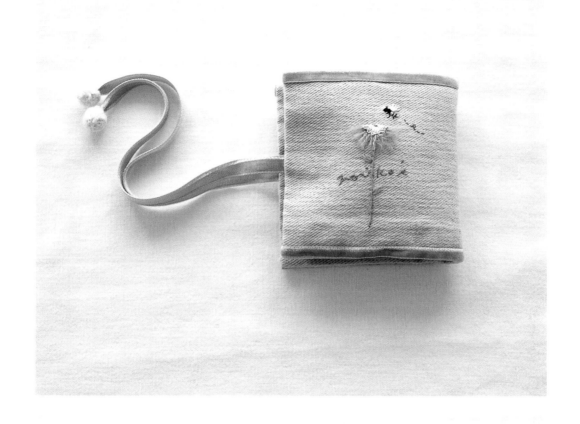

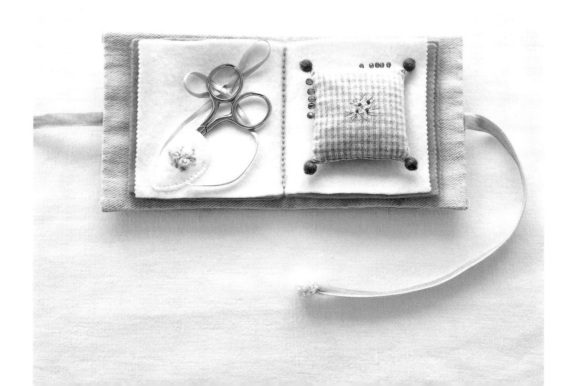

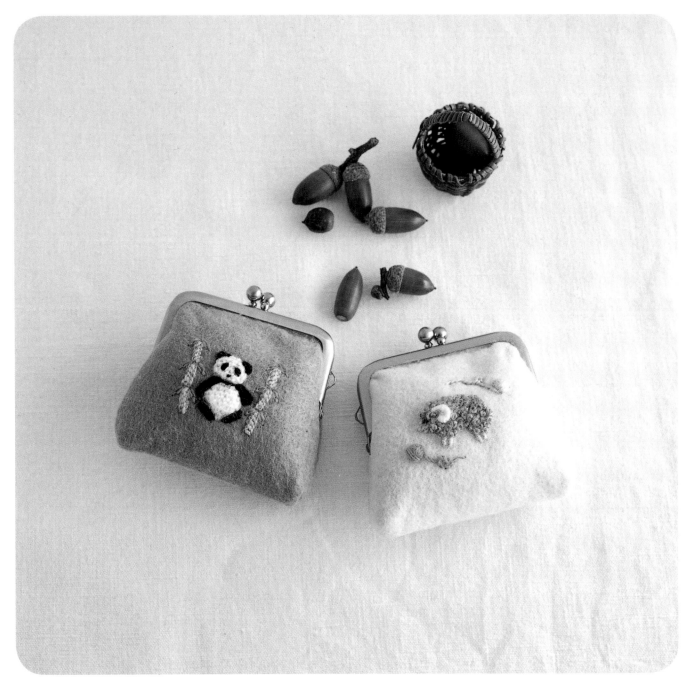

Clasp Purse

This charming panda makes me want to pet it with my fingers, and is made from a 3-D embroidery called stumpwork. If you put a small sheet of felt in its tummy, it stands out even more. French knots on the sheep's body give a soft, woolen touch.

See page 58 for pattern instructions.

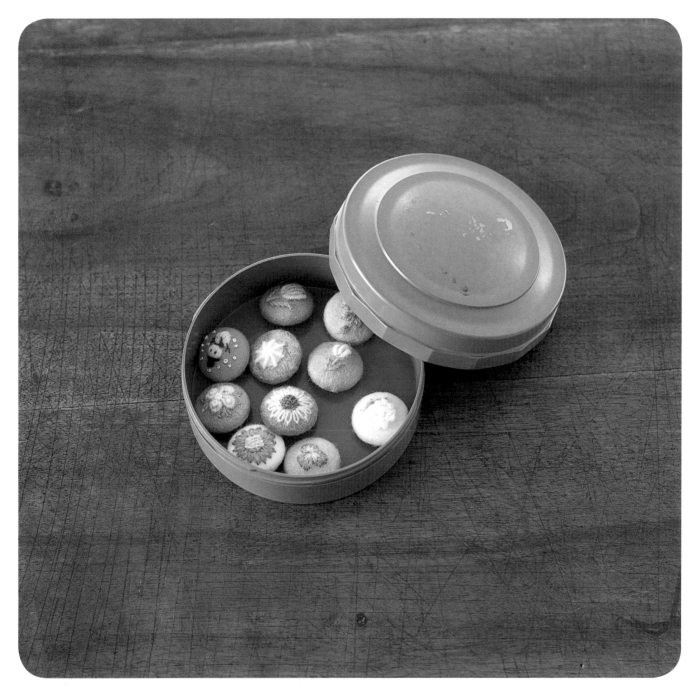

Covered Buttons

These buttons are used not only for clothes, but also for bags, brooches, and more. You can make various kinds of buttons with leftover wool.

See page 59 for
pattern instructions.

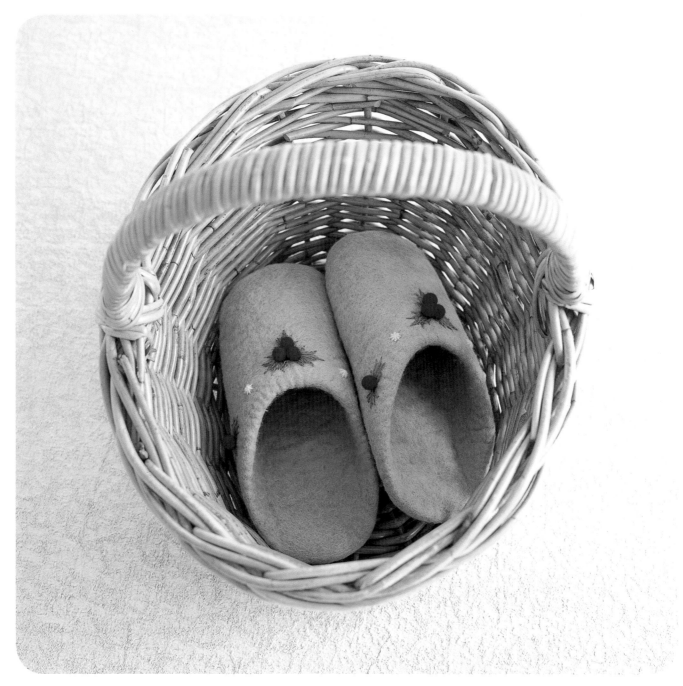

⊪ Felt Slippers and Holiday Socks

Embroider your own design on store-bought slippers to give as a holiday gift. You can tailor the socks into a tapestry work, or choose one sock to use as a greeting card.

See page 60 for pattern instructions.

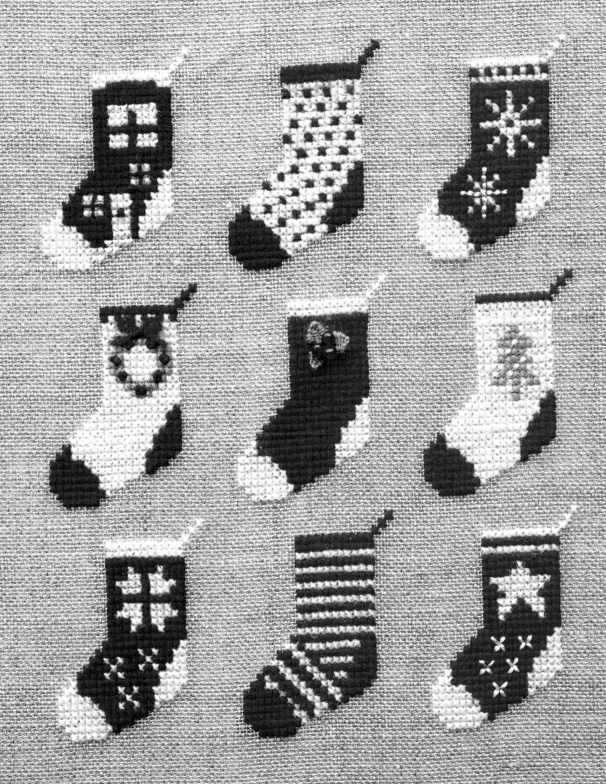

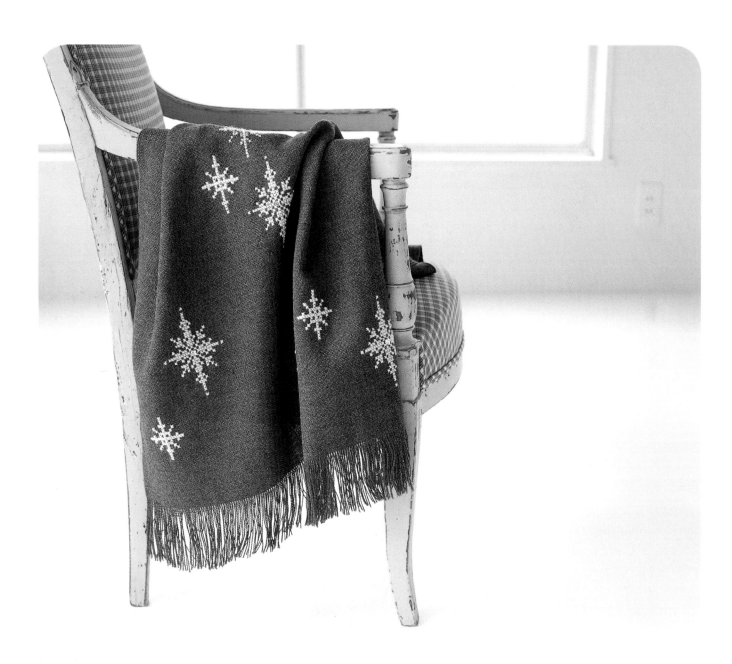

◐ Stole

Cross-stitch snow crystals on this large, simple stole and add an elegant shine
by decorating the stole with rhinestones.

*See page 54 for
pattern instructions.*

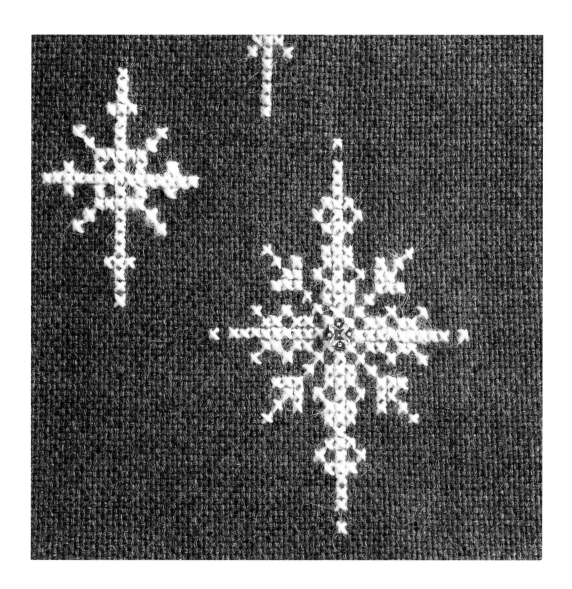

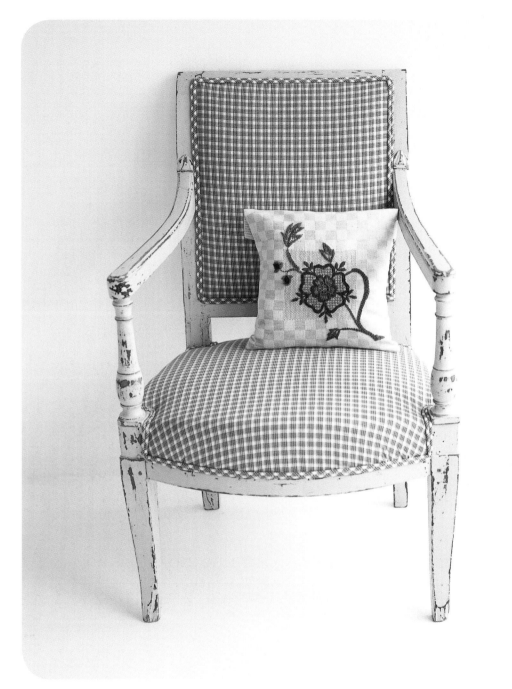

Mini Cushion

Crewel embroidery is also called Jacobean embroidery. This has a typical flower
motif for this mini cushion.

See page 62 for
pattern instructions.

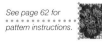

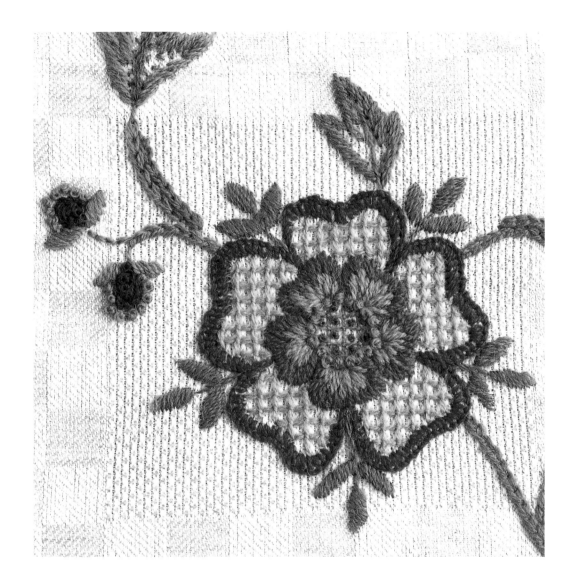

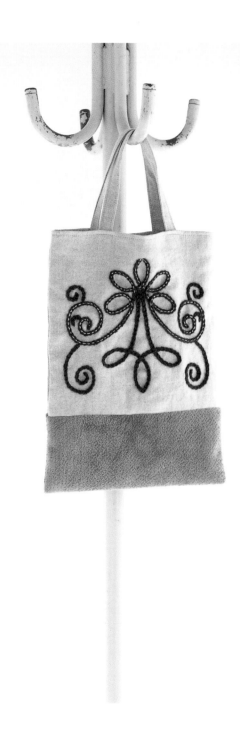

Handbag

The arabesque pattern on this bag is made with chain stitches and backstitches. The wool and lamé thread combination adds a moderate brilliance to the work.

See page 64 for pattern instructions.

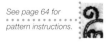

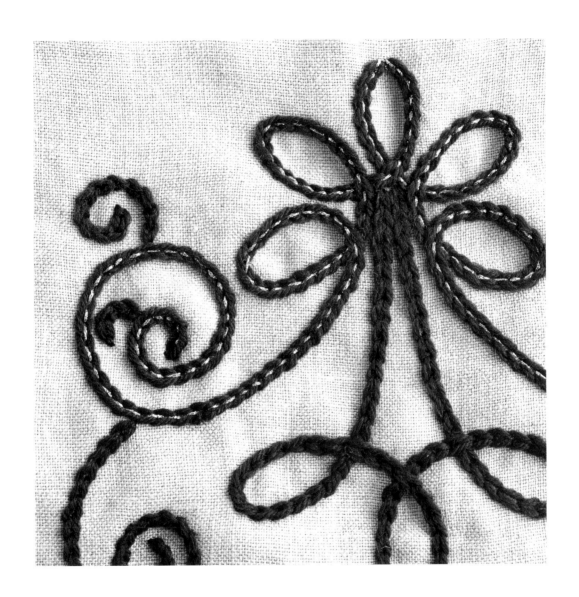

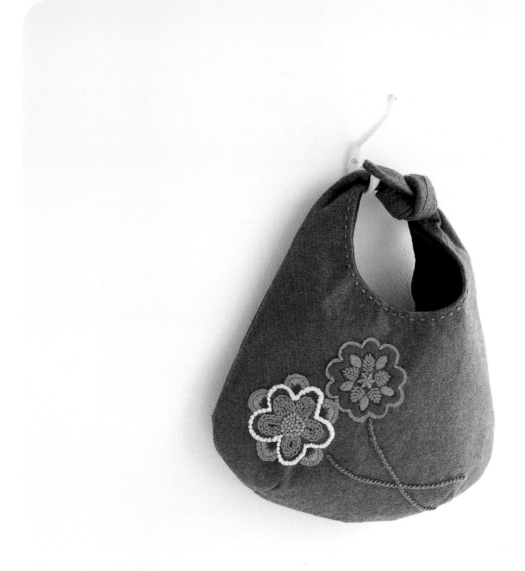

❙❙ Wool Handbag

The vivid, blue flowers bloom on a chic, brown background, which makes for
an unusual design.

*See page 65 for
pattern instructions.*

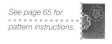

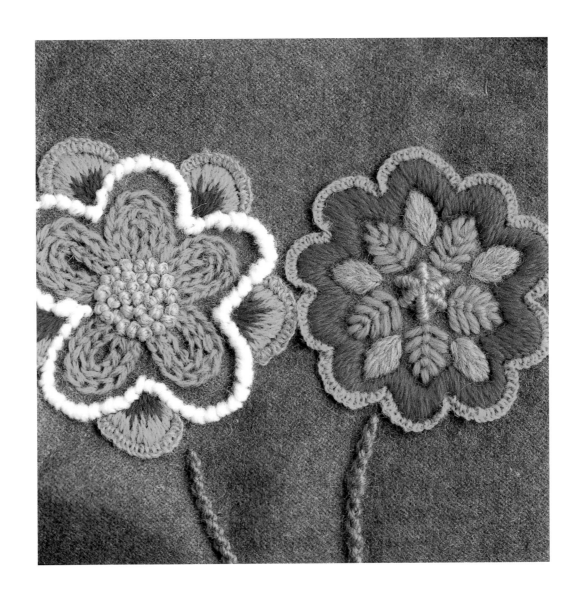

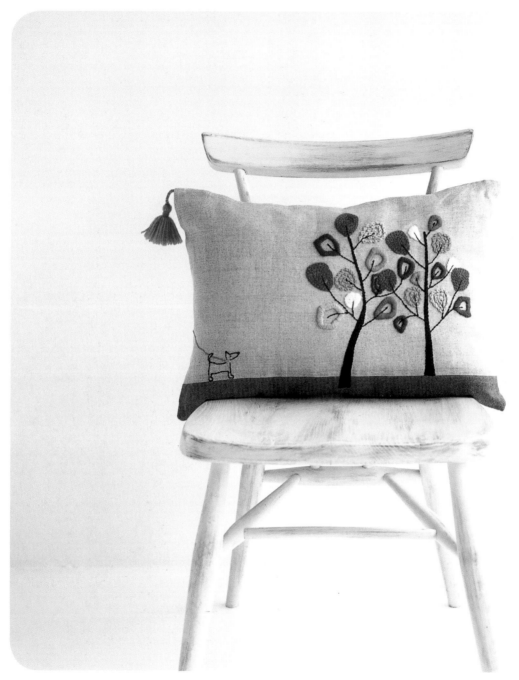

Cushion

A dog stops to look up at the colored trees. This design seems to have a story.
Finish this embroidery with motifs using different weights of wool.

See page 71 for
pattern instructions.

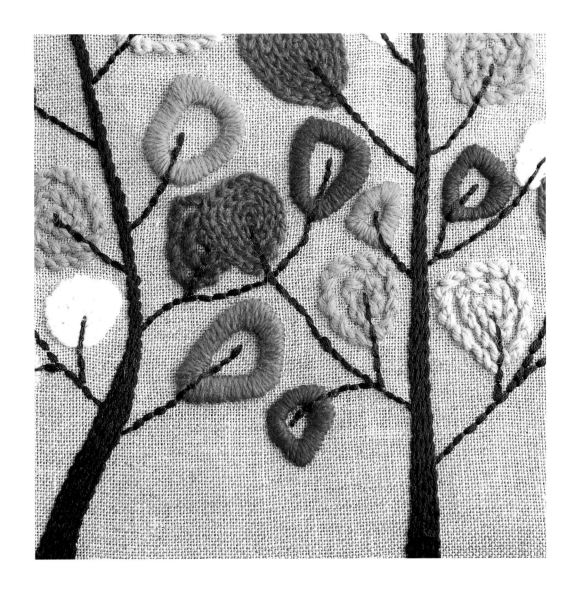

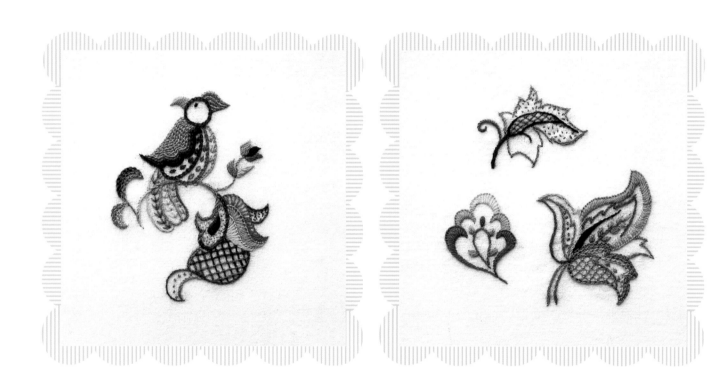

▍Mini Picture Frame

This pattern showing tree, deer, and bird motifs is a typical crewel embroidery motif. Finish the work with easy stitches.

See page 68 for
pattern instructions.

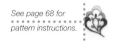

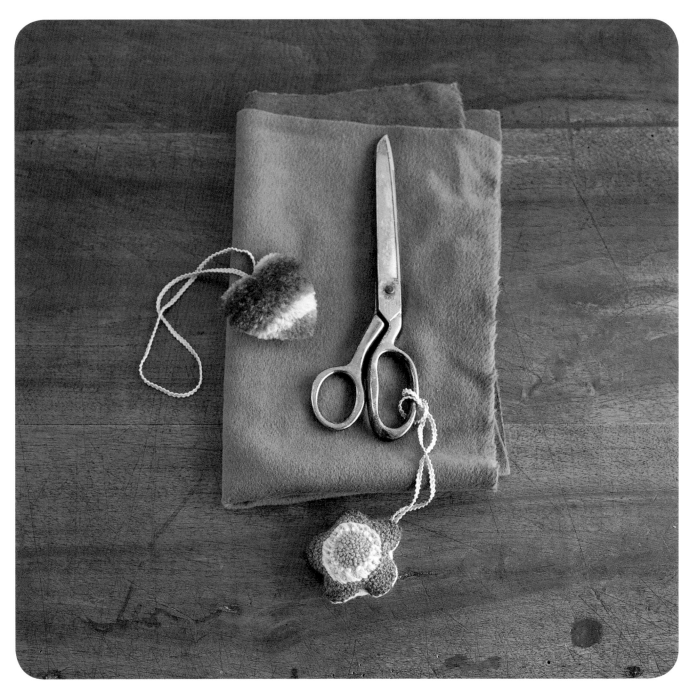

Scissors Strap

When you are engrossed in embroidering, sometimes you get irritated looking for your pair of scissors. You no longer need to panic if you hook your scissors with a strap. You can also use this strap as a handbag accessory, mobile phone strap, and more. Use your creativity.

See page 74 for pattern instructions.

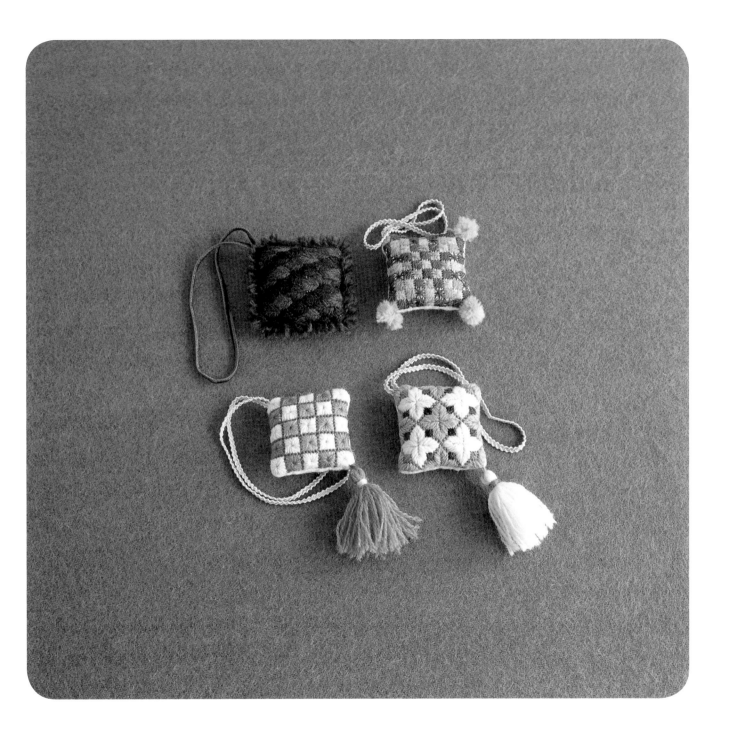

Guide to Wool Embroidery

You can use any kind of wool for wool embroidery, but you need to choose well. Thick wool, for example, may not go through a particular piece of fabric or the needle's eye. Low loft thread may also break, and the mohair may easily come off on heavy-use items.

An embroidery hoop can straighten the fabric and facilitate needlework, but a hoop should not be used for stretchable fabrics, such as wool. This section presents a basic guide to wool materials, needles, and other useful tools for wool embroidery.

● Wool

Use small rolls of embroidery wool. Wool rubs against the cloth while needling and breaks easily, so it should be cut to the desired length. The recommended length is 12–20 inches (30–50 cm).

Appleton Crewel Wool

This low loft wool is mothproof. It is ultrafine and easy to handle. Its thickness can be adjusted by changing the number of strands.

Anchor Tapestry Wool

This is thick wool suitable for use on a canvas net, or other types of rough embroidery.

DMC #25 Tapestry Wool

This is the same type of thick wool as Anchor Tapestry Wool, but it has a rich color and velvety texture.

Madeira Lana Wool

This wool comes in a variety of colors suitable for a wide range of uses, such as machine embroidery, quilting, hand embroidery, and more.

TEC Mohair (Japanese local thread)

This wool adds a soft finish to your work. A long strand may break easily because of its fluffiness, so it should be cut relatively short for stitching. (Wisper sells a nice mohair equivalent in the U.S.)

Special Ultrafine Wool (Japanese local thread)

Ultrafine wool is generally rolled in a ball or skein to give ample quantity for your work. It is also suitable for crochet and knitting. (Misti Alpaca Lace is a nice ultrafine wool skein option in the U.S.)

Other Wool

Coats & Clark, Diadem Art. 5374
Matalbon Embroidery Thread (Japanese local thread)
Anchor #25 Embroidery Thread
Anchor Marlitt

● Needles

An embroidery needle has a larger eye than that of a sewing needle, so the thread passes easily through the eye. The higher the number of the needle, the finer and shorter it is. You should choose a needle that is appropriate for the strands and the embroidering fabric.

● Embroidery Needles

Both the embroidery needle and the chenille needle have sharp points and are suitable for fine textures, such as linen cloth. A needle for ribbon embroidery also has a sharp point and is good for the same textures. A tapestry needle and a cross-stitch needle, on the other hand, have round points that do not break the thread or texture, and are suitable for loose textures or canvas, where you can count the stitches when embroidering.

Sample Needles

 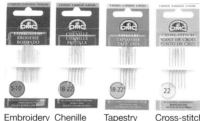

| Embroidery Needle | Chenille Needle | Tapestry Needle | Embroidery Needle | Chenille Needle | Tapestry Needle | Cross-stitch Needle |

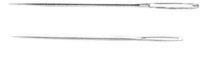

Chenille Needle

This needle is thicker and has a larger eye than an embroidery needle, so it is suitable for embroidering with a thick piece of thread on a hemp cloth. You can substitute with an embroidery needle when embroidering with fine thread on a piece of cloth.

Tapestry Needle or Cross-Stitch Needle

This needle has round points that do not break the thread, and it goes through the fabric and between threads smoothly. It is suitable for counting stitches when working on cross-stitches and half cross-stitches.

Left: Sharp tip of chenille needle
Right: Round tip of tapestry or cross-stitch needle

● Embroidery Hoop

There are various sizes of embroidery hoops. Choose the right size for your embroidery design. It is difficult to embroider when a design is as large as the size of the hoop, so choose one that leaves some room around the design. When embroidering on a large design, such as a piece of tablecloth, move the hoop gradually as you work on it. To use the hoop, loosen the screw to remove the outer frame, then position the design on the inner frame. Cover the outer frame as you carefully stretch the fabric, then tighten the screw.

Useful Tools and Materials

● Tailor's Chalk Paper and Tracer

When you copy a free embroidery or stumpwork design, use a tailor's chalk paper and a tracer. First, copy the design on tracing paper, then cover the fabric with a sheet of chalk paper and place the design on it. Trace the design carefully with a tracer, making sure you don't move the paper or fabric. You may want to carefully tape the edges together.

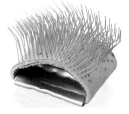

● Thimble-Type Nap Brush

This brush is used for making animal's hair like the samples shown on pages 8 and 9. Stroke the surface of the embroidery to nap it. You should not stroke it too hard or else the wool will come off.

● Waste Canvas

The waste canvas is useful for cross-stitching on a fine texture, to make it easier to count stitches. It is also handy for embroideries on bags and blouses that you can buy at stores. There are several types of waste canvases, classified by the numbers of stitches, so you can choose a suitable size for your embroidery design. The photos below show stitches in different colors at equal intervals, to illustrate this easy method for counting stitches.

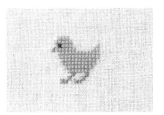

1 Cut the waste canvas a little larger than the embroidery design you plan to make, and baste it on the fabric. Count the woven strings on the canvas in order to stitch the right number of stitches as you embroider, and pay attention to the direction of the cross-stitches. The work will be beautifully finished if you embroider it a little tightly, because the waste canvas will be pulled out afterwards.

2 The embroidery is finished.

3 Pull out the basting thread, then undo the canvas threads one by one. Pull out both the warp and the weft of the canvas.

4 The work is finished.

Thread Colors Reference Charts

Here you'll find common colors used in embroidery and in many of the patterns in this book. Use the Guide to Wool Embroidery to help you choose your own colors or to make substitutions for threads not included in these charts.

● Appleton Crewel Wool

(for pages 46–47, 52–53, 62, 65–69, 70–73, 74–77)

Number	Color
105	Pansy purple dark
106	Pansy purple very dark
144	Old rose bright
145	Old rose medium
146	Old rose medium dark
159	Sea green very dark
183	Bunny brown medium
186	Bunny brown dark
204	Beige brown medium dark
205	Russet red medium
206	Russet red medium dark
207	Russet red dark
208	Russet red bright
209	Russet red very dark
242	Moss green light
245	Moss green very dark
252	Leaf green medium light
255	Leaf green dark
256	Leaf green very dark
301	Antique brown very light
303	Antique brown medium
312	Yellow ochre medium light
313	Yellow ochre medium
314	Yellow ochre
315	Yellow ochre dark
321	Williamsburg blue very light
323	Williamsburg blue medium light
327	Williamsburg blue dark
334	Avocado green dark
335	Avocado green medium dark
336	Avocado green very dark
341	Meadow green very light
342	Meadow green light
343	Meadow green medium light
345	Meadow green medium
346	Meadow green dark
347	Meadow green
355	Pistachio green dark
357	Pistachio green
401	Forest green light
426	Holly green dark
484	Electric blue medium dark
485	Electric blue dark
504	Chinese red medium
505	Chinese red dark
544	Renaissance green medium light
547	Renaissance green medium
548	Renaissance green very dark
584	Burnt umbre medium dark
609	Soft mauve burnt medium
626	Burnt orange dark
692	Palomino gold very light
694	Palomino gold medium light
695	Palomino gold medium
696	Palomino gold medium dark
697	Palomino gold
711	Bordeaux very light
713	Antique mauve dark
715	Bordeaux dark
716	Bordeaux very dark
722	Cinnamon medium
723	Cinnamon medium dark
725	Cinnamon very dark
751	Crimson tide very light
754	Crimson tide medium light
765	Sable brown medium
766	Sable brown dark
767	Sable brown very dark
824	Ultramarine medium dark
841	Hellenic gold very light
842	Hellenic gold light
844	Hellenic gold bright light
863	Mahogany
866	Pumpkin dark
881	Orchid light
911	Maple brown medium
913	Maple brown dark
916	Maple brown
925	Atlantic blue medium dark
927	Atlantic blue ultra dark
991B	White

● Anchor Tapestry Wool

(for pages 64–67, 71–73)

Number	Color
8004	White
8100	Amber
8164	Rust orange
8166	Rust orange light

8236	Paprika
8686	Cornflower blue
8690	Cornflower blue medium
8808	Turquoise
9098	Apple green
9100	Apple green medium
9602	Mahogany
9654	Chocolate light
9658	Chocolate

● DMC #25 Tapestry Wool

(for pages 55–57, 59)

310	Black
320	Medium pistachio green
522	Fern green
524	Very light fern green
839	Dark beige brown
3755	Baby blue
3799	Very dark pewter gray
B5200	White
	Ecru

● Madeira Lana Wool

(for pages 48–49)

3625	Temple gold
3686	Pale Gray
3808	Teak
3831	Espresso
3832	Light brown
3837	Pewter
3840	Tawny tan
3841	Khaki
3842	Oatmeal
3843	Mahogany
3844	Earthy rose

3881	Gray
3887	Fawn
3889	Dark cinnamon
3892	Black
3898	Light khaki
3903	Medium army green
3906	Dark army green

● Special Ultrafine Wool

Japanese local thread

(for pages 50–51, 60–61)

1	White
3	Black
9	Light green
35	Red
42	Mauve
44	Beige
51	Chocolate brown
58	Light pink
79	Turquoise

● TEC Mohair

Japanese local thread

(for pages 52–60, 63)

2	Moss green
3	Green
7	Dark pink
13	Medium pink
14	Very light pink
19	Light pink
25	Dark brown
26	Dark green
27	Light green
41	Ivory
42	Cream

61	Medium gray
62	Brown
63	Gray-brown
66	Beige
74	Light gray
75	Dark gray
81	Off-white
82	Blue
96	Rose
500	White
	Black

● Coats & Clark, Diadem Art. 5374

(for page 64)

300	Gold

● Matalbon Embroidery Thread

Japanese local thread

(for page 65)

609	Brown

● Anchor #25 Embroidery Thread

(for page 71)

382	Mocha brown
944	Light brown

● Anchor Marlitt

(for pages 55–57, 59, 61)

800	White
872	Gray brown very light
1012	Yellow very light
1034	Off-white

How to Stitch

Types of Stitches and How to Make Them

The diagrams on pages 41–45 illustrate how many of the stitches used in this book are made. There are various stitch techniques, such as free embroidery, cross-stitch, crewelwork, stumpwork, canvas work, and more. The numbered steps on the diagrams show how to make each stitch. "In" means your needle should go through the fabric's top (right) side; "out" indicates when to bring the needle up from the bottom (wrong) side. Refer to the pattern photos and this section as you work each pattern. In no time at all, you'll be an expert at wool embroidery! In these patterns, the word "stitch" is abbreviated with "S."

● Straight stitch

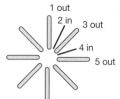
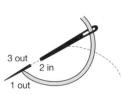

● Outline or stem stitch

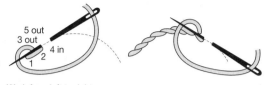

Work from left to right.

● Running stitch

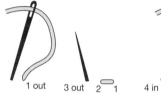

Make stitches equal length on top and half that size in the underside.

● Back stitch

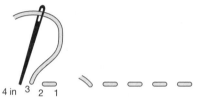

Make small backward stitches.

● Seed stitch

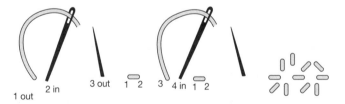

Make straight stitches in any pattern.

● Fly stitch

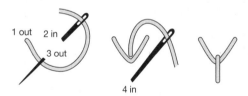

Stitch downward to hold the thread in place.

● Couching

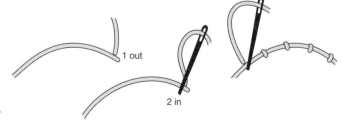

Work over the top of the thread.

● Coral stitch

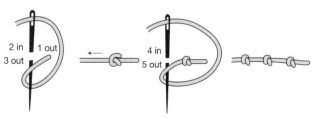

Lay the thread along the design, then stitch under the thread.

● Satin stitch

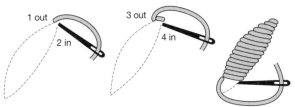

Make straight stitches to fill in a design.

● Satin stitch with core

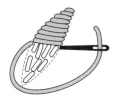

When you want to increase the thickness of your work, work running stitches in the inner part of the design, which serves as the core; then work satin stitches over the running stitches.

● Fern stitch

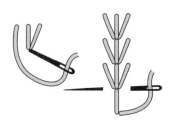

Make three straight stitches.

● Long and short stitch

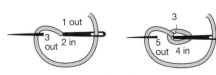

Alternate long and short stitches for a smooth look.

● Lazy daisy stitch

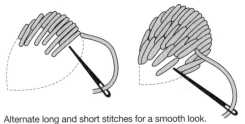

Make a loop and tack it down.

● Chain stitch

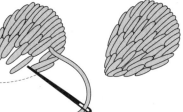

Loop the thread around the needle.

● Feather stitch

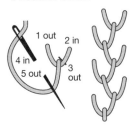

Make downward stitches on the same level, alternating right and left. Pull through with the thread under the needle point.

● Twisted chain stitch

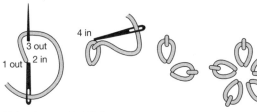

Insert the needle close to the last loop and make a small slanting stitch.

● Macrame stitch

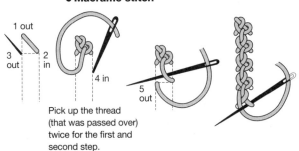

Pick up the thread (that was passed over) twice for the first and second step.

● French knot

 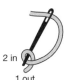 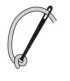 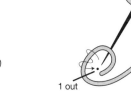 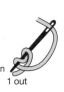 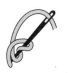

1 out · 2 in · 1 out

Encircle the needle one or two times with the thread to make a knot.

● Bullion stitch

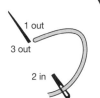 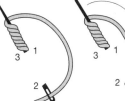 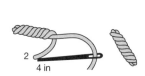

1 out · 3 out · 2 in · 3 · 1 · 2 · 3 · 1 · 2 · 2 · 4 in

Coil the thread around the needle and pull it through.

● Bullion knot

 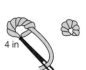

1 out · 3 out · 2 in · 4 in

● Leaf stitch

The finish looks like a fishbone stitch (see below), but the needling is different.

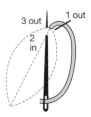 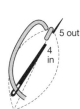 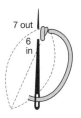 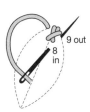

3 out · 1 out · 2 in · 5 out · 4 in · 7 out · 6 in · 8 in · 9 out

● Fishbone stitch

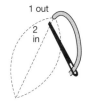 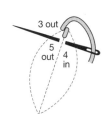 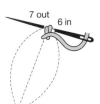 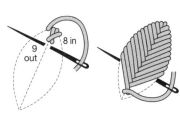

1 out · 2 in · 3 out · 5 out · 4 in · 7 out · 6 in · 8 in · 9 out

● Spiderweb rose (or woven wheel) stitch

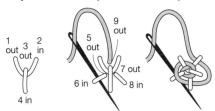

1 out · 2 in · 3 out · 4 in · 5 out · 9 out · 6 in · 7 out · 8 in

Weave under and over the straight stitches.

● Fill stitch

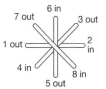

7 out · 6 in · 3 out · 1 out · 2 in · 4 in · 5 out · 8 in

Begin in the center and work outward.

● Couched trellis stitch

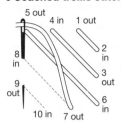

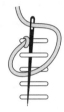

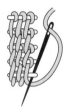

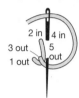

When needling in a cross pattern, work horizontally first, then vertically.

● Buttonhole (or blanket) stitch

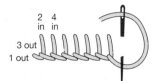

Make a downward stitch with the thread under the needle and pull through to form a loop

● Raised buttonhole stitch

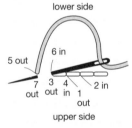

1 out ⊂══⊃ 2 in
4 in ⊂══⊃ 3 out

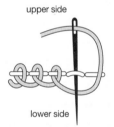

Work buttonhole stitches without needling the fabric.

● Closed buttonhole stitch

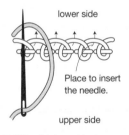

2 in 4 in
3 out 5
1 out out

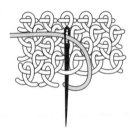

● Detached buttonhole stitch

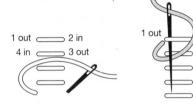

lower side

5 out
6 in
7 3 4 2 in
out out in 1
 out

upper side

Work back stitches and pull out the needle from the bottom of the fifth step.

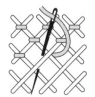

upper side

lower side

Pick up each stitch to work a buttonhole stitch.

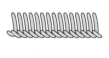

lower side

Place to insert the needle.

upper side

Hold the fabric upside down, and insert the needle through the stitches of the previous row and pull through.

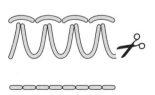

Pull the needle through the loop in the same way, and fasten off behind to finish.

● Raised leaf stitch

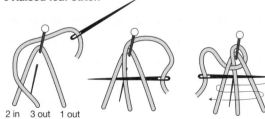

2 in 3 out 1 out

Use a marking pin to hold the center of the thread as the core. Cast the needle through three strings in the core thread, as indicated in the diagram, without piercing the fabric, then pull out the marking pin to finish.

● Smyrna (or Palestrina) stitch

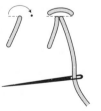

Reverse side

Needle on the fabric while making loops, and cut the loop at the end.

● Cross stitch

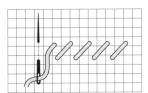

Work sideways while needling from right to left.

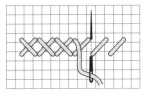

Then, needle all the way back from left to right.

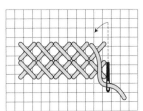

After completing one row, start a new row above.

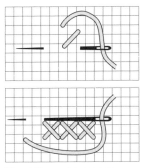

Completing each cross and continuing sideways.

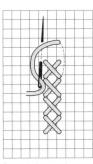

Completing each cross and continuing upward.

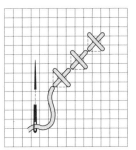

Completing each cross and continuing diagonally.

● Holbein (or double running) stitch

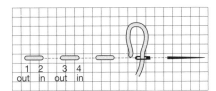

Work a row of evenly spaced stitches.

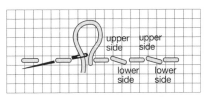

Then, work back across the row, filling in the spaces made on the first journey. The needle is always pulled out from the lower position and inserted into the upper position.

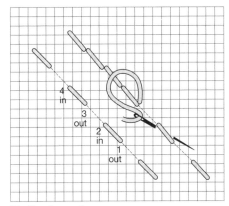

Working diagonally.

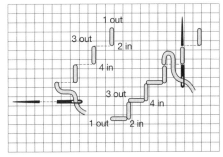

Working a stairlike design.

● Date Book Planner Cover

See page 6 for photo and page 38 for Thread Colors Reference Charts.

Materials

Fabric hemmed to dimensions of 4.3 in x
6.3 in (11 cm x 16 cm)

Thread

Appleton Crewel Wool

242 Moss green light
245 Moss green very dark
252 Leaf green medium light
255 Leaf green dark
256 Leaf green very dark
312 Yellow ochre medium light
313 Yellow ochre medium
314 Yellow ochre
315 Yellow ochre dark
355 Pistachio green dark
357 Pistachio green
504 Chinese red medium
505 Chinese red dark
544 Renaissance green
 medium light
547 Renaissance green
 medium

548 Renaissance green very
 dark
694 Palomino gold medium
 light
695 Palomino gold medium
696 Palomino gold medium
 dark
715 Bordeaux dark
716 Bordeaux very dark
722 Cinnamon medium
723 Cinnamon medium dark
725 Cinnamon very dark
925 Atlantic blue medium dark
927 Atlantic blue ultra dark

Align the center and the design of the
date book planner cover. Copy the
design and embroider.

Full-scale embroidery design #1

Use a single strand of thread unless otherwise indicated.

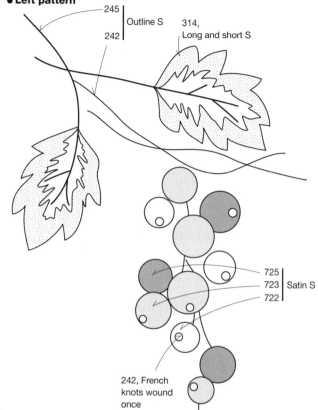

● **Left pattern**

245 ⎤ Outline S
242 ⎦

314,
Long and short S

725 ⎤
723 ⎥ Satin S
722 ⎦

242, French
knots wound
once

● **Right pattern**

255 256
Outline S

505 ⎤ Use double strands
 ⎥ proportionally, to achieve
 ⎥ the light/dark effect
504 ⎦ Work and fill inside with
 French knots wound twice

256

255

505, Work and fill
inside with French
knots wound twice

255 ⎤
 ⎥ Long and
 ⎥ short S
252 ⎦

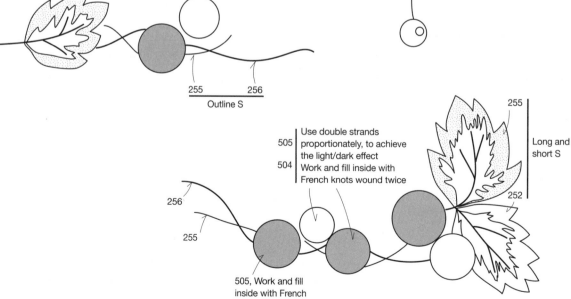

Full-scale embroidery design #2 (See page 7 for photo.)

Use a single strand of thread and outline stitches unless otherwise indicated.

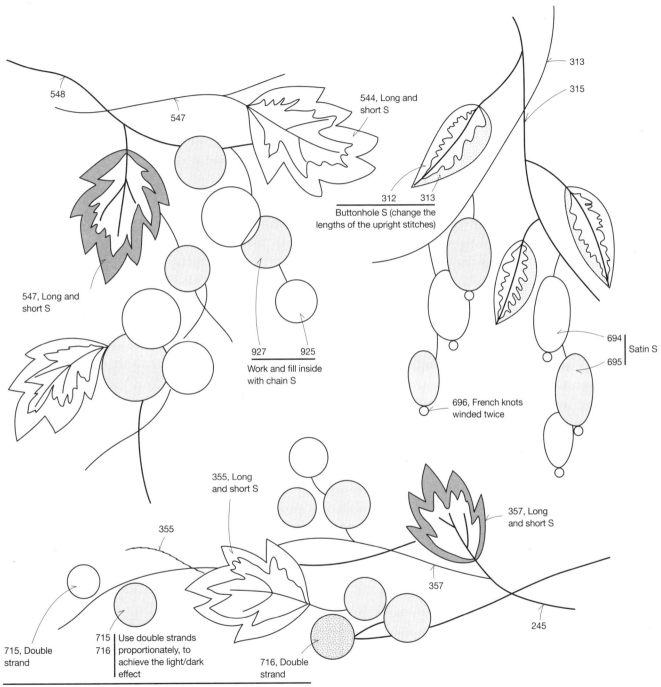

548

547

544, Long and
short S

313

315

312 313
Buttonhole S (change the
lengths of the upright stitches)

547, Long and
short S

694 ⎤
 ⎥ Satin S
695 ⎦

927 925
Work and fill inside
with chain S

696, French knots
winded twice

355, Long
and short S

357, Long
and short S

355

357

245

715, Double
strand

715 ⎤ Use double strands
716 ⎦ proportionately, to
 achieve the light/dark
 effect

716, Double
strand

Work and fill inside with French knots wound twice

● Accessory Boxes

See page 8 for photo and page 38 for
Thread Colors Reference Charts.
● ●
Materials

Fabric

Hemp cloth: (Squirrel) Light yellow
 brown, 8 in (20 cm) square;
 (Acorn) Beige, 6 in (15 cm) square

Thread

Madeira Lana #12 Wool
 Embroidery Thread

3625 Temple gold	3844 Earthy rose
3686 Pale gray	3881 Gray
3808 Teak	3887 Fawn
3831 Espresso	3889 Dark cinnamon
3832 Light brown	3892 Black
3837 Pewter	3898 Light khaki
3840 Tawny tan	3903 Medium army
3841 Khaki	green
3842 Oatmeal	3906 Dark army
3843 Mahogany	green

Wooden box with squirrel: 2 in x 2 in
 (5 cm x 5 cm) deep octagon box
Wooden box with acorn: 1.8 in x 2.4 in
 (4.5 cm x 6 cm) deep hexagon box

Napper

Copy the design on the center of the
fabric, then embroider. Nap the fabric with
a napper and attach it to the box lid.

Full-scale embroidery design #1

Use double strands of thread. For combined threads, use double strands of two
different colors as indicated in the diagrams below. Coordinate the colors and
fill in with outline stitches unless otherwise indicated. Nap the shaded parts after
completing the embroidery.

● Squirrel

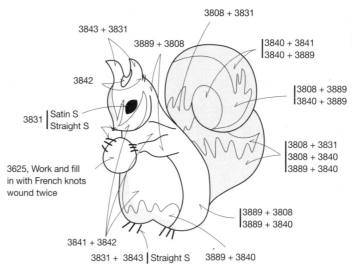

● Acorn

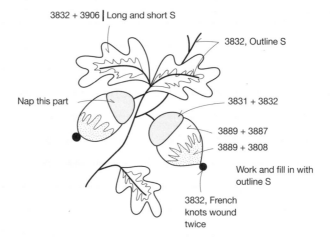

48

Full-scale embroidery design #2 (See page 9 for photo.)

Use double strands of Madeira Lana #12 Wool Embroidery Thread. For combined threads, use double strands of two different colors as indicated in the diagrams below. Nap the shaded parts.

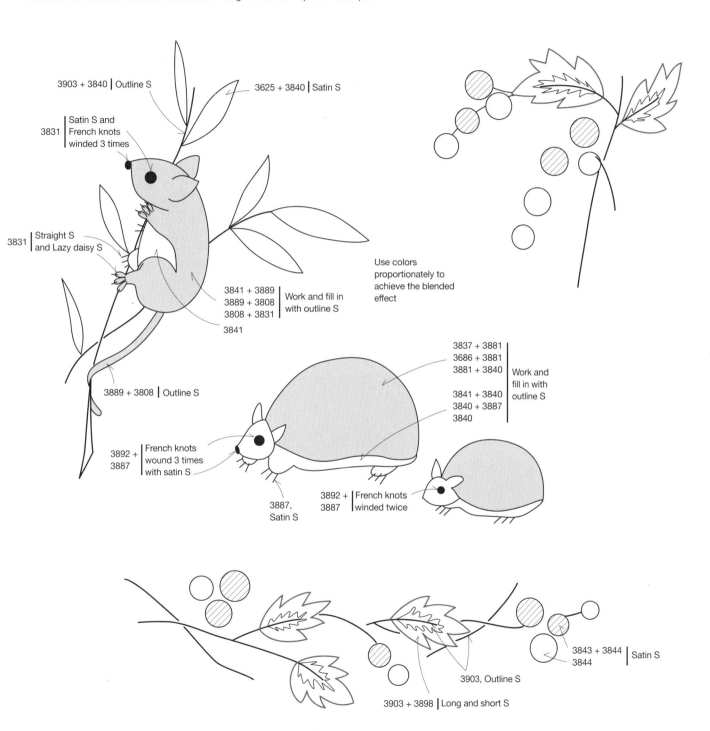

3903 + 3840 | Outline S

3625 + 3840 | Satin S

3831 | Satin S and French knots winded 3 times

3831 | Straight S and Lazy daisy S

3841 + 3889
3889 + 3808
3808 + 3831 | Work and fill in with outline S
3841

3889 + 3808 | Outline S

Use colors proportionately to achieve the blended effect

3837 + 3881
3686 + 3881
3881 + 3840 | Work and fill in with outline S
3841 + 3840
3840 + 3887
3840

3892 + 3887 | French knots wound 3 times with satin S

3887, Satin S

3892 + 3887 | French knots winded twice

3903 + 3898 | Long and short S

3903, Outline S

3843 + 3844
3844 | Satin S

49

● Bag and Purse

*See page 10 for photo and page 38 for
Thread Colors Reference Charts.*

Materials

Fabric

Bag: Gray fleece, 7.5 in x 8.3 in
 (19 cm x 21 cm)
Purse: Gray fleece, 5 in x 4 in
 (13 cm x 10 cm)

Thread

*Special Ultrafine Wool (Japanese
 local thread)*
3 Black
42 Mauve
44 Beige
51 Chocolate brown
58 Light pink
79 Turquoise

Other materials

Waste canvas, 4 in (10 cm) = 71 x 71
 stitches

Stitches

One square in the design = 2 x 2 stitches
 of waste canvas

Place the waste canvas on the
foundation, then align the center of the
design and the foundation. Work cross
stitches.

Embroidery design #1

● Bag

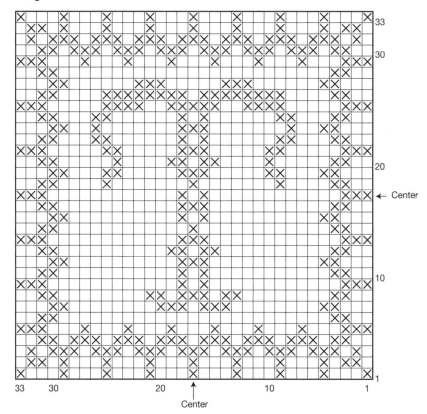

● Purse

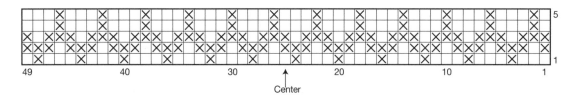

Use a single
strand and
work cross S

$\boxed{\times}$ =3

Embroidery design #2 (See page 11 for photo.)

Use a single strand of black or other colors of wool as pictured.
Use a waste canvas, 4 in (10 cm) = 71 x 71 stitches.
Stitches: one square in the design = 2 x 2 stitches of waste canvas.

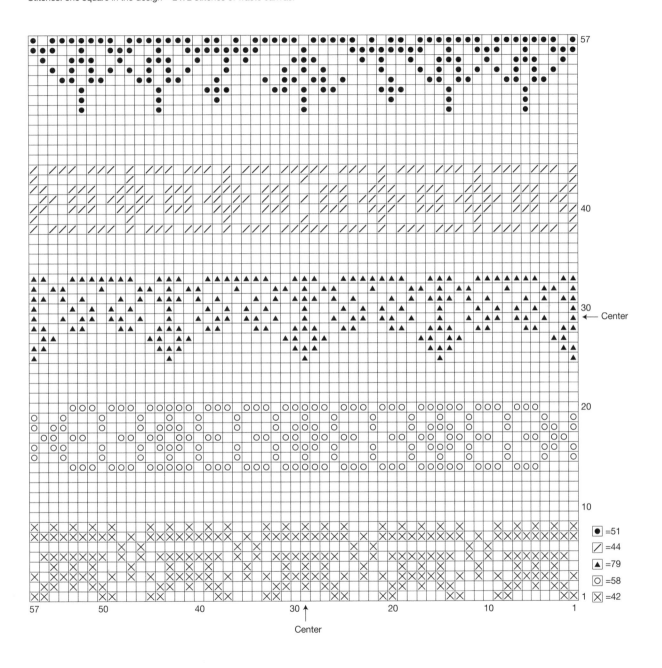

●	=51
╱	=44
▲	=79
○	=58
✕	=42

● Mini Purse

See page 12 for photo and page 38 for
Thread Colors Reference Charts.

Materials

Fabric

Half-finished purse, 4.3 in wide x 4 in
 deep (11 cm x 10 cm)

Thread

Appleton Crewel Wool (CW)

146 Old rose	696 Palomino gold
medium dark	medium dark
206 Russet red	697 Palomino gold
medium dark	863 Mahogany
207 Russet red dark	866 Pumpkin dark
313 Yellow ochre medium	911 Maple brown
314 Yellow ochre	medium
334 Avocado green dark	913 Maple brown
336 Avocado green	dark
very dark	

TEC Mohair (TM), Japanese local thread

13 Medium pink
14 Very light pink
61 Medium gray
96 Rose

Align the center of the purse and the
design, then copy and embroider.

Full-scale embroidery design #1

Use a single strand of thread unless otherwise indicated.

CW = Crewel Wool

TM = TEC Mohair

● **Black purse**

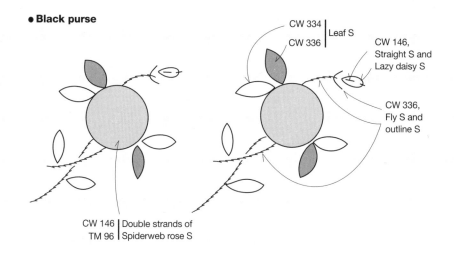

CW 334 ⎤
CW 336 ⎦ Leaf S

CW 146,
Straight S and
Lazy daisy S

CW 336,
Fly S and
outline S

CW 146 ⎤ Double strands of
TM 96 ⎦ Spiderweb rose S

● **Wine red purse**

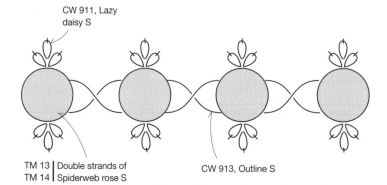

CW 911, Lazy
daisy S

TM 13 ⎤ Double strands of
TM 14 ⎦ Spiderweb rose S

CW 913, Outline S

Full-scale embroidery design #2 (See page 13 for photo.)
Use a single strand of thread unless otherwise indicated.
CW = Crewel Wool
TM = TEC Mohair

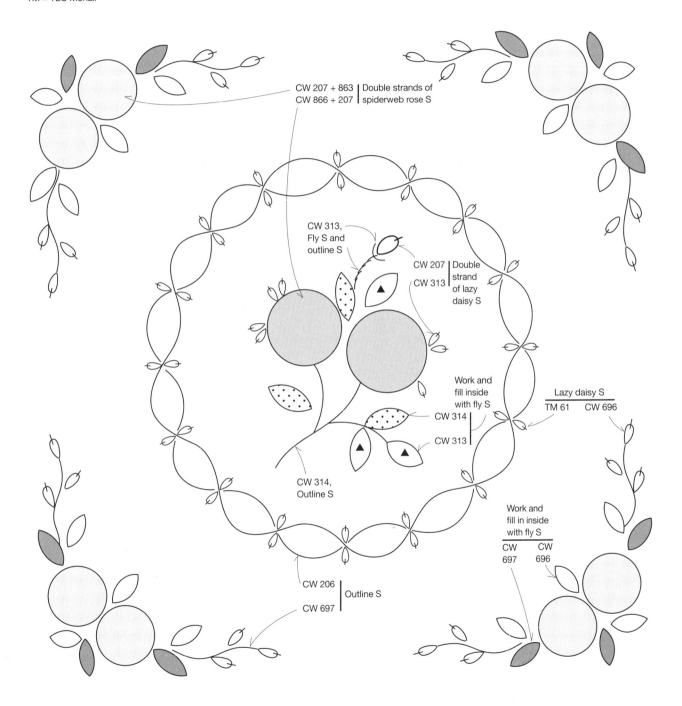

CW 207 + 863 | Double strands of
CW 866 + 207 | spiderweb rose S

CW 313,
Fly S and
outline S

CW 207 | Double
 | strand
CW 313 | of lazy
 | daisy S

Work and
fill inside
with fly S

CW 314

CW 313

Lazy daisy S
TM 61 CW 696

CW 314,
Outline S

Work and
fill in inside
with fly S

CW CW
697 696

CW 206 | Outline S
CW 697 |

● Stole

See page 20 for photo and page 38 for Thread Colors Reference Charts.

Materials

Fabric

Gray wool stole, 24 in x 71 in (60 cm x 180 cm), including fringe; 4 in rough square (10 cm square) = 64 x 58 stitches of fabric

Thread

TEC Mohair (Japanese local thread)
74 Light gray
500 White, 1 roll

Other materials

3 rhinestones, 2.4 in (6 cm) square

Stitches

One square in the design = 2 x 2 stitches of fabric

Align the design and the stole, then embroider with cross-stitches. Place the rhinestones.

Use a single strand of thread
Cross S

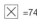 =74

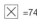 =500

=Position for placing the rhinestones

Embroidery designs

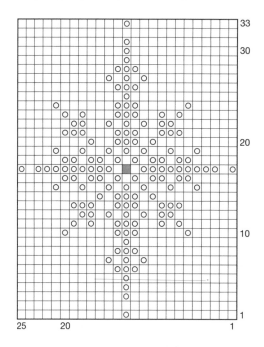

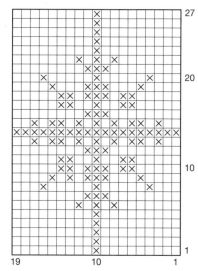

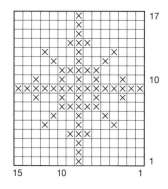

● Embroidery positions

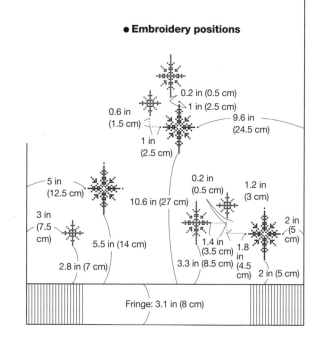

54

● Sewing Kit Case

See pages 14–15 for photo and page 38 for Thread Colors Reference Charts.

Materials

Fabric

Beige brushing denim: 9.8 in x 10.2 in
 (25 cm × 26 cm)
Felt: Blue, two 8 in (20 cm) squares;
 white, 7.1 in x 5.5 in (18 cm × 14 cm)
Checkered cotton cloth: 3.1 in x 5.5 in
 (8 cm × 14 cm)
Cotton organdy: 4 in x 2 in (10 cm × 5 cm)

Thread

TEC Mohair (TM), Japanese local thread

3 Green	63 Gray-brown
7 Dark pink	82 Blue
19 Light pink	500 White
41 Ivory	Black

DMC #25 Tapestry Wool

310 Black	3755 Baby blue
320 Medium	3799 Very dark
pistachio green	pewter gray
522 Fern green	B5200 White
524 Very light fern	Ecru
green	

Anchor Marlitt (AM)

872 Gray brown very light
1012 Yellow very light
1034 Off-white

Other materials

Beige velvet ribbon: 2 strands of 0.4 in x
 9.4 in (0.9 cm × 24 cm); 2 strands of
 0.2 in x 10.2 in (0.6 cm × 26 cm)
Blue satin ribbon: 13.8 in x 0.1 in
 (35 cm x 0.3 cm)
4 wooden beads, 0.2 in (0.6 cm) diameter
2 white woolen balls, 0.5 in (1.2 cm)
 diameter
1 white Velcro button, 0.8 in (2 cm)
 diameter
Synthetic fiber cotton

Finished size

4.3 in x 4.1 in (11 cm × 10.5 cm)

Copy the design onto each section and embroider, then finish according to the diagrams on pages 56–57.

Full-scale embroidery design

Use a single strand of DMC #25 embroidery thread unless otherwise indicated.

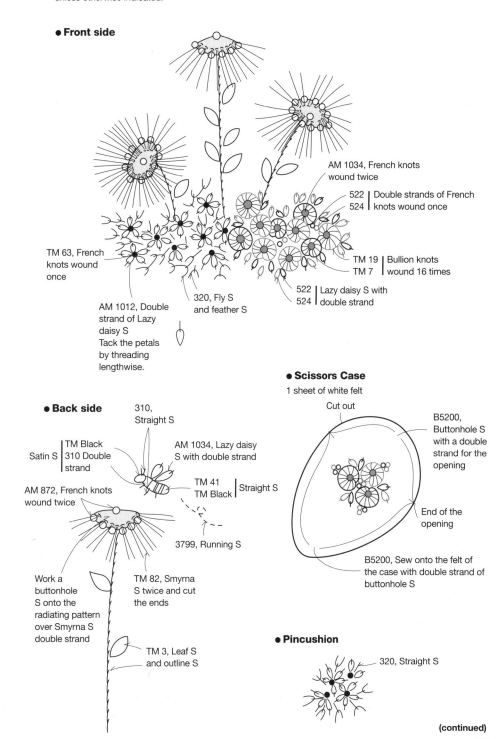

● **Front side**

AM 1034, French knots wound twice

522 | Double strands of French
524 | knots wound once

TM 19 | Bullion knots
TM 7 | wound 16 times

522 | Lazy daisy S with
524 | double strand

320, Fly S and feather S

TM 63, French knots wound once

AM 1012, Double strand of Lazy daisy S Tack the petals by threading lengthwise.

● **Back side**

310, Straight S

Satin S | TM Black
| 310 Double
| strand

AM 1034, Lazy daisy S with double strand

TM 41
TM Black | Straight S

AM 872, French knots wound twice

3799, Running S

Work a buttonhole S onto the radiating pattern over Smyrna S double strand

TM 82, Smyrna S twice and cut the ends

TM 3, Leaf S and outline S

● **Scissors Case**

1 sheet of white felt

Cut out

B5200, Buttonhole S with a double strand for the opening

End of the opening

B5200, Sew onto the felt of the case with double strand of buttonhole S

● **Pincushion**

320, Straight S

55

Measurements

● Main fabric: 1 sheet of brushing denim

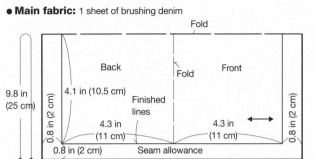

Fold

Back

Front

Fold

4.1 in (10.5 cm)

Finished lines

9.8 in (25 cm)

0.8 in (2 cm)

4.3 in (11 cm)

4.3 in (11 cm)

0.8 in (2 cm)

0.8 in (2 cm)

Seam allowance

10.2 in (26 cm)

● Inner cloth: felt

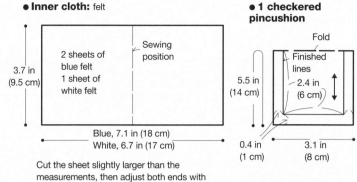

3.7 in (9.5 cm)

2 sheets of blue felt
1 sheet of white felt

Sewing position

Blue, 7.1 in (18 cm)
White, 6.7 in (17 cm)

Cut the sheet slightly larger than the measurements, then adjust both ends with pinking shears

● 1 checkered pincushion

Fold

Finished lines

5.5 in (14 cm)

2.4 in (6 cm)

0.4 in (1 cm)

3.1 in (8 cm)

● Front side

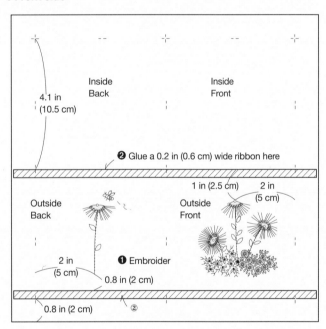

Inside Back

Inside Front

4.1 in (10.5 cm)

❷ Glue a 0.2 in (0.6 cm) wide ribbon here

Outside Back

Outside Front

1 in (2.5 cm)

2 in (5 cm)

2 in (5 cm)

❶ Embroider

0.8 in (2 cm)

0.8 in (2 cm)

②

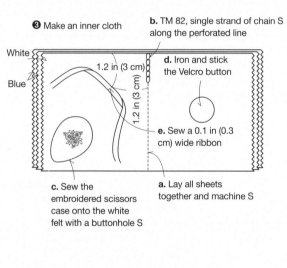

❸ Make an inner cloth

b. TM 82, single strand of chain S along the perforated line

White

Blue

1.2 in (3 cm)

1.2 in (3 cm)

d. Iron and stick the Velcro button

e. Sew a 0.1 in (0.3 cm) wide ribbon

c. Sew the embroidered scissors case onto the white felt with a buttonhole S

a. Lay all sheets together and machine S

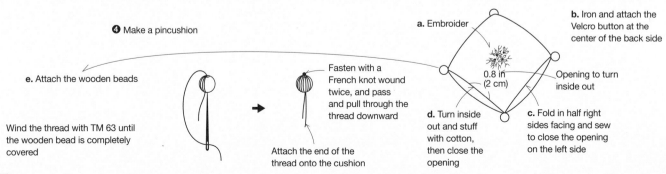

❹ Make a pincushion

e. Attach the wooden beads

Wind the thread with TM 63 until the wooden bead is completely covered

Fasten with a French knot wound twice, and pass and pull through the thread downward

Attach the end of the thread onto the cushion

a. Embroider

b. Iron and attach the Velcro button at the center of the back side

0.8 in (2 cm)

Opening to turn inside out

d. Turn inside out and stuff with cotton, then close the opening

c. Fold in half right sides facing and sew to close the opening on the left side

56

❺ Make a belt

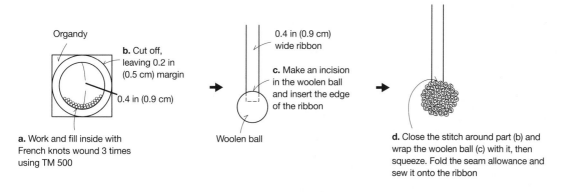

Organdy

b. Cut off, leaving 0.2 in (0.5 cm) margin

0.4 in (0.9 cm)

a. Work and fill inside with French knots wound 3 times using TM 500

0.4 in (0.9 cm) wide ribbon

c. Make an incision in the woolen ball and insert the edge of the ribbon

Woolen ball

d. Close the stitch around part (b) and wrap the woolen ball (c) with it, then squeeze. Fold the seam allowance and sew it onto the ribbon

❻ Insert the belt and sew up the main part

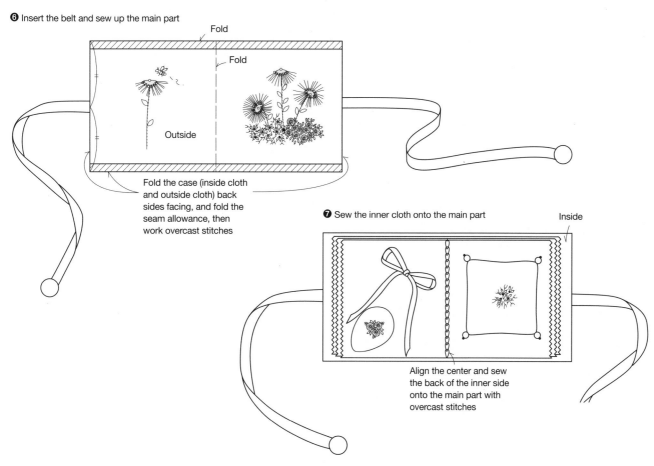

Fold

Fold

Outside

Fold the case (inside cloth and outside cloth) back sides facing, and fold the seam allowance, then work overcast stitches

❼ Sew the inner cloth onto the main part

Inside

Align the center and sew the back of the inner side onto the main part with overcast stitches

● Clasp Purse

See page 16 for photo and page 38 for Thread Colors Reference Charts.

● ●

Materials

Fabric

Felt clasp purse: approx. 3.3 in x
2.8 in (8.5 cm x 7 cm); Panda = Rose
pink; Sheep = Off-white

Thread

TEC Mohair (Japanese local thread)

7 Dark pink	75 Dark gray
26 Dark green	82 Blue
27 Light green	500 White
66 Beige	Black

Other materials

White felt for panda

Align the center of the clasp purse and
the design, then copy it and embroider.

Full-scale embroidery design

Use a single strand of thread

● Panda

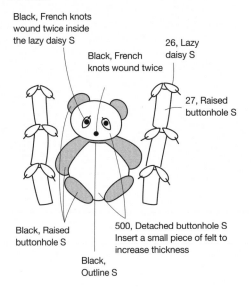

Black, French knots
wound twice inside
the lazy daisy S

Black, French
knots wound twice

26, Lazy
daisy S

27, Raised
buttonhole S

Black, Raised
buttonhole S

500, Detached buttonhole S
Insert a small piece of felt to
increase thickness

Black,
Outline S

● Sheep

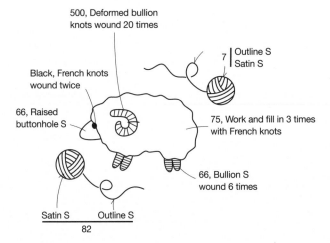

500, Deformed bullion
knots wound 20 times

Black, French knots
wound twice

Outline S
7 | Satin S

66, Raised
buttonhole S

75, Work and fill in 3 times
with French knots

66, Bullion S
wound 6 times

Satin S Outline S
82

Pile up satin stitches for the wool balls to increase the thickness.

● Covered Buttons

See page 17 for photo and page 38 for Thread Colors Reference Charts.

Materials

Fabric

Circle of felt, 2 in (5 cm) diameter for each
 button

Thread

TEC Mohair (TM), Japanese local thread

3 Green	63 Gray-brown
19 Light pink	66 Beige
26 Dark green	81 Off-white
27 Light green	500 White
41 Ivory	Black
42 Cream	

DMC #25 Tapestry Wool (DM)
321 Red
839 Dark beige brown
3799 Very dark pewter gray

Anchor Marlitt (AM)
800 White

Other materials

Covered buttons with shank, 1 in (2.5 cm)
 diameter

Copy the design onto the center of
the felt and embroider. Close stitch
on the edge and ring it while wrapping
the button.

Full-scale embroidery design

Use a single strand of thread unless otherwise indicated
DM = DMC #25
AM = Anchor Marlitt
TM = TEC Mohair

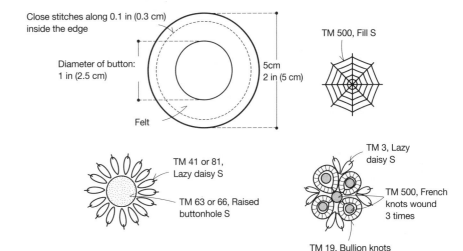

Close stitches along 0.1 in (0.3 cm)
inside the edge

Diameter of button:
1 in (2.5 cm)

5cm
2 in (5 cm)

Felt

TM 500, Fill S

TM 41 or 81,
Lazy daisy S

TM 63 or 66, Raised
buttonhole S

TM 3, Lazy
daisy S

TM 500, French
knots wound
3 times

TM 19, Bullion knots
wound 16 times

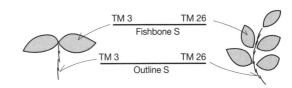

TM 3 TM 26
Fishbone S

TM 3 TM 26
Outline S

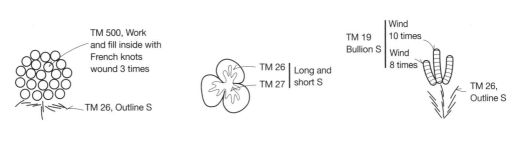

TM 500, Work
and fill inside with
French knots
wound 3 times

TM 26, Outline S

TM 26
TM 27 | Long and
short S

TM 19
Bullion S

Wind
10 times
Wind
8 times

TM 26,
Outline S

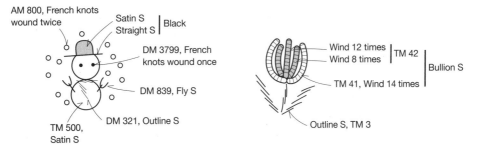

AM 800, French knots
wound twice

Satin S
Straight S | Black

DM 3799, French
knots wound once

DM 839, Fly S

DM 321, Outline S

TM 500,
Satin S

Wind 12 times
Wind 8 times | TM 42

TM 41, Wind 14 times

Bullion S

Outline S, TM 3

● Felt Slippers

See page 18 for photo and page 38 for Thread Colors Reference Charts.

Materials

Fabric
Beige felt slippers, size 7 (9.8 in; 25 cm)

Thread
TEC Mohair (TM), Japanese local thread
2 Moss green

Special Ultrafine Wool (SP), Japanese local thread
1 White
35 Red

Other materials
10 red wooden beads, 0.4 in (1 cm) diameter

Copy the design on the top of the arch as indicated in the diagram below, then embroider.

Full-scale embroidery design

Use a single strand of thread
TM = TEC Mohair
SP = Special Ultrafine Wool, Japanese local thread

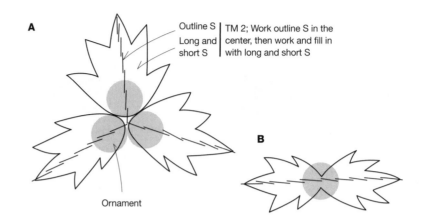

A

Outline S | TM 2; Work outline S in the
Long and | center, then work and fill in
short S | with long and short S

Ornament

B

C
SP 1, Fill S, 0.4 in (1 cm) diameter

Embroidery arrangement

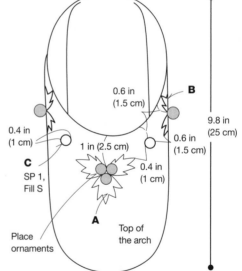

0.6 in (1.5 cm)

B

9.8 in (25 cm)

0.4 in (1 cm)

1 in (2.5 cm)

0.6 in (1.5 cm)

C
SP 1, Fill S

0.4 in (1 cm)

A

Top of the arch

Place ornaments

● Making the ornaments

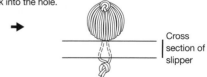

10 wooden beads

Hole

Wooden bead

SP 35, Single strand

Pass the thread through the hole of a wooden bead and wrap it until the surface is completely covered.

After wrapping, pull the thread through to the top, and make a French knot wound twice, then put it back into the hole.

Cross section of slipper

Attach the ornaments onto the slippers and make a knot, then fasten off.

● Holiday Socks

See page 19 for photo and page 38 for Thread Colors Reference Charts.

Materials

Fabric
Hemp cloth, 4 in (10 cm)
 square = 110 x 110
 stitches

Thread
Use a single strand of
 Special Ultrafine Wool
 (Japanese local thread)
 unless otherwise noted

*Special Ultrafine Wool
(Japanese local thread)*
1 White
9 Light green
35 Red

Anchor Marlitt (AM)
800 White

Stitches
One square in the design
 = 2 x 2 stitches of the
 cloth

3 gem beads; optional

Cross S

 35

○ 1

□ 9

 AM 800, Double
 strand

Holbein S

⌣ 35

⌣ AM 800, Double
 strand

Embroidery designs

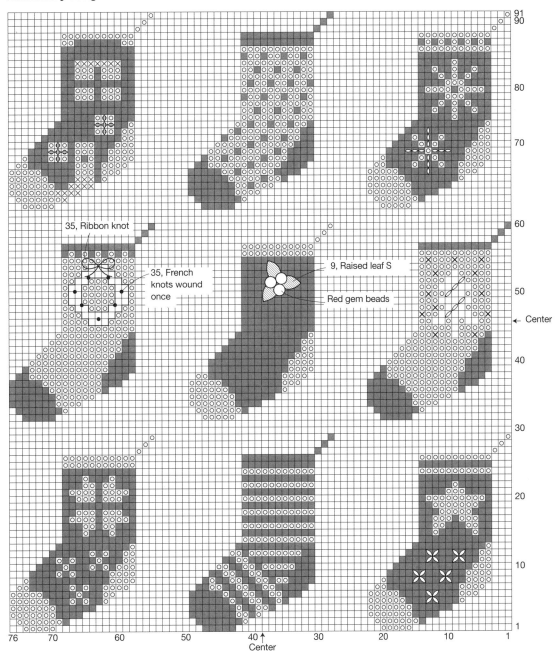

35, Ribbon knot

35, French knots wound once

9, Raised leaf S

Red gem beads

← Center

Center

● Mini Cushion

*See page 22 for photo and page 38 for
Thread Colors Reference Charts.*

Materials

Fabric

Beige hemp cloth, 29.1 in x 12.6 in
(74 cm × 32 cm)

Thread

Appleton Crewel Wool

204 Beige brown medium dark	315 Yellow ochre dark
205 Russet red medium	335 Avocado green medium dark
206 Russet red medium dark	695 Palomino gold medium
207 Russet red dark	696 Palomino gold medium dark
208 Russet red bright	765 Sable brown medium
209 Russet red very dark	766 Sable brown dark
313 Yellow ochre medium	767 Sable brown very dark
314 Yellow ochre	

Other materials

12 in (30 cm) square plain cushion

Finished measurements

11.4 in (29 cm) square

Copy the design onto the fabric and
embroider as shown in the diagram. Then,
assemble the cushion. If it is too tight,
adjust the volume of the stuffing.

Half-scale embroidery design

Use double strands of thread unless
otherwise indicated

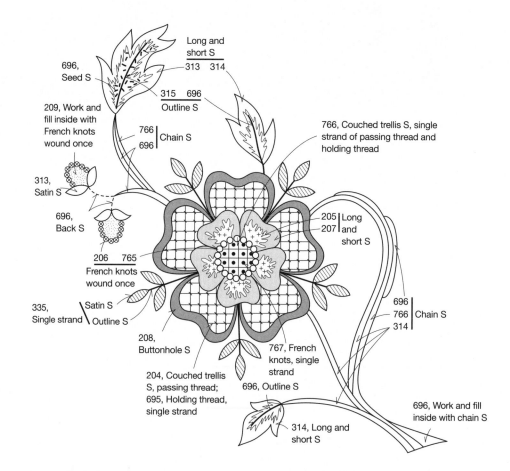

696, Seed S

Long and short S
313 314

315 696
Outline S

209, Work and fill inside with French knots wound once

766
696 Chain S

766, Couched trellis S, single strand of passing thread and holding thread

313, Satin S

696, Back S

206 765
French knots wound once

205
207 Long and short S

335, Single strand Satin S / Outline S

696
766 Chain S
314

208, Buttonhole S

767, French knots, single strand

696, Outline S

204, Couched trellis S, passing thread; 695, Holding thread, single strand

696, Work and fill inside with chain S

314, Long and short S

Measurements

Finish both ends with a zigzag sewing machine stitch

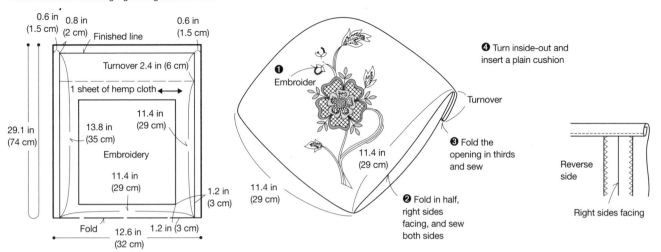

0.6 in (1.5 cm) 0.8 in (2 cm) Finished line 0.6 in (1.5 cm)

Turnover 2.4 in (6 cm)

1 sheet of hemp cloth

29.1 in (74 cm)

13.8 in (35 cm)

11.4 in (29 cm)

Embroidery

11.4 in (29 cm)

1.2 in (3 cm)

Fold 12.6 in (32 cm) 1.2 in (3 cm)

❶ Embroider

❹ Turn inside-out and insert a plain cushion

Turnover

❸ Fold the opening in thirds and sew

11.4 in (29 cm)

11.4 in (29 cm)

❷ Fold in half, right sides facing, and sew both sides

Reverse side

Right sides facing

● Sheep Motif

See page 5 for photo and page 38 for Thread Colors Reference Charts.

Materials

Fabric

Hemp cloth, 4 in (10 cm) square = 110 x 110 stitches

Thread

TEC Mohair (Japanese local thread)
62 Brown
500 White

Full-scale embroidery design

Use a single strand

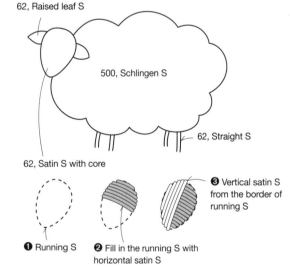

62, Raised leaf S

500, Schlingen S

62, Straight S

62, Satin S with core

❸ Vertical satin S from the border of running S

❶ Running S

❷ Fill in the running S with horizontal satin S

Schlingen Stitch

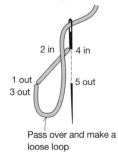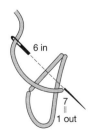

2 in 4 in

1 out
3 out 5 out

Pass over and make a loose loop

6 in

7 = 1 out

Repeat steps 2 to 7

● Handbag
See page 24 for photo and page 38 for Thread Colors Reference Charts.

............................

Materials

Fabric
Hemp handbag with fake fur, 9.4 in x
 12.6 in (24 cm × 32 cm)

Thread
Anchor Tapestry Wool (TW)
9602 Mahogany, 2 rolls

Coats & Clark, Diadem Art. 5374 (CC)
300 Gold

Align the center of the handbag and the
design, then copy it and embroider. Close
up the bottom of the lining.

Embroidery design
Enlarge by 125 percent

CC 300, Back S
over chain S

TW 9602, Chain
S, single strand

● Wool Handbag

See page 26 for photo and page 38 for Thread Colors Reference Charts.

Materials

Fabric

Mocha brown flannel cloth, 27.6 in x 22.4 in (70 cm × 57 cm)
Mocha brown cotton cloth for lining, 33.5 in x 22.4 in (85 cm × 57 cm)

Thread

Anchor Tapestry Wool (TW)
8004 White
8808 Turquoise
8100 Amber
8690 Cornflower blue medium
9098 Apple green
9658 Chocolate

Appleton Crewel Wool (CW)
426 Holly green dark
484 Electric blue medium dark
485 Electric blue dark
824 Ultramarine medium dark

Matalbon Embroidery Thread (ME), Japanese local thread
609 Brown

Other materials

Adhesive core, 33.5 in x 22.4 in (85 cm × 57 cm)

Finished size: See page 66.
Enlarge the patterns and connect them before cutting out the fabric. Copy the design on the front side and embroider, then finish according to the assembly patterns.

Half-scale embroidery design

Use a single strand of thread unless otherwise indicated.
TW = Tapestry Wool
CW = Crewel Wool

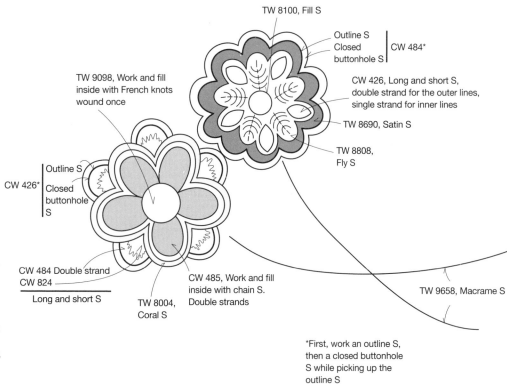

TW 8100, Fill S

Outline S
Closed buttonhole S | CW 484*

CW 426, Long and short S, double strand for the outer lines, single strand for inner lines

TW 8690, Satin S

TW 8808, Fly S

TW 9098, Work and fill inside with French knots wound once

CW 426*

Outline S
Closed buttonhole S

CW 484 Double strand
CW 824

Long and short S

TW 8004, Coral S

CW 485, Work and fill inside with chain S. Double strands

TW 9658, Macrame S

*First, work an outline S, then a closed buttonhole S while picking up the outline S

(continued)

● Wool Handbag assembly pattern

See page 26 for photo and page 38 for
Thread Colors Reference Charts.

Main part

Fabric (see page 65)
2 sheets each:
Outer flannel fabric
Cotton lining

Adhesive core
Cut out with 0.4 in (1 cm) seam.
Paste the adhesive core.

● Half-scale design

● Inside pocket

Fabric
1 sheet each:
Cotton fabric
Adhesive core, 5 in x 3.5 in (13 cm × 9 cm)

0.4 in (1 cm) for seam allowance.
Paste an adhesive core on the back part.

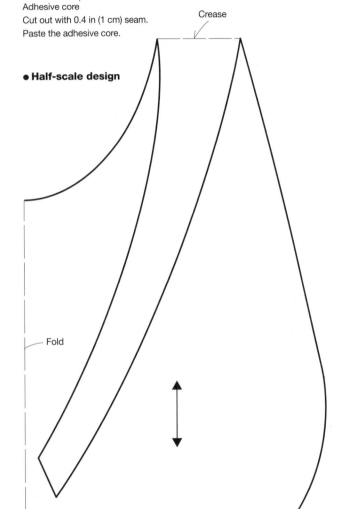

Crease

Fold

Dart

Center

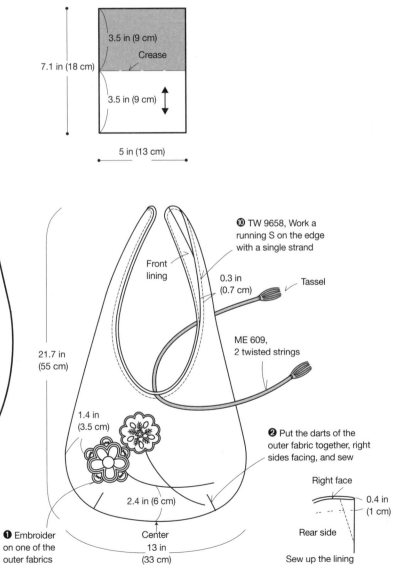

7.1 in (18 cm)

3.5 in (9 cm)

Crease

3.5 in (9 cm)

5 in (13 cm)

❿ TW 9658, Work a running S on the edge with a single strand

Front lining

0.3 in (0.7 cm)

Tassel

ME 609, 2 twisted strings

21.7 in (55 cm)

1.4 in (3.5 cm)

2.4 in (6 cm)

❶ Embroider on one of the outer fabrics

Center
13 in (33 cm)

❷ Put the darts of the outer fabric together, right sides facing, and sew

Right face

0.4 in (1 cm)

Rear side

Sew up the lining

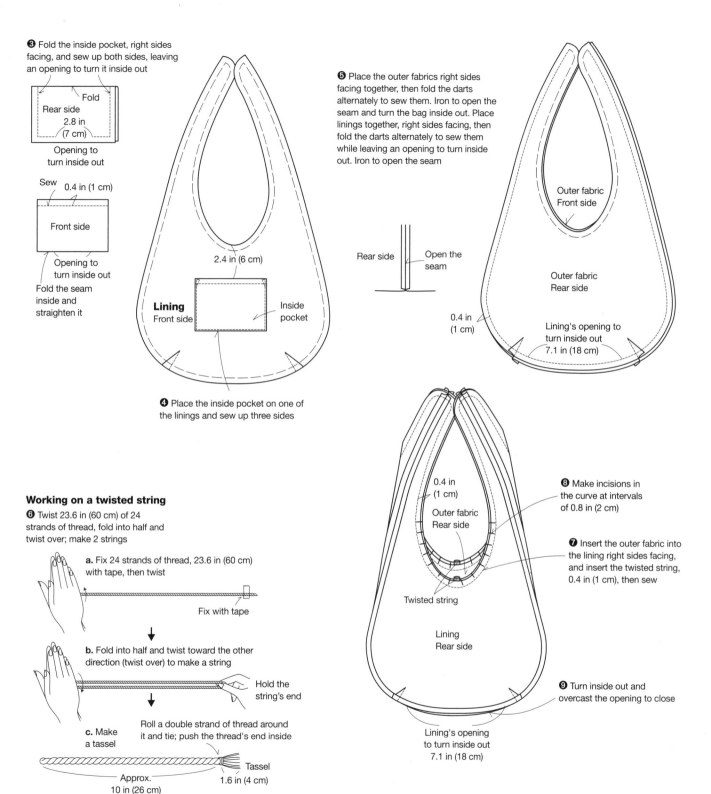

❸ Fold the inside pocket, right sides facing, and sew up both sides, leaving an opening to turn it inside out

Fold

Rear side
2.8 in
(7 cm)

Opening to
turn inside out

Sew
0.4 in (1 cm)

Front side

Opening to
turn inside out

Fold the seam
inside and
straighten it

2.4 in (6 cm)

Lining
Front side

Inside
pocket

❹ Place the inside pocket on one of the linings and sew up three sides

❺ Place the outer fabrics right sides facing together, then fold the darts alternately to sew them. Iron to open the seam and turn the bag inside out. Place linings together, right sides facing, then fold the darts alternately to sew them while leaving an opening to turn inside out. Iron to open the seam

Rear side

Open the
seam

0.4 in
(1 cm)

Outer fabric
Front side

Outer fabric
Rear side

Lining's opening to
turn inside out
7.1 in (18 cm)

Working on a twisted string

❻ Twist 23.6 in (60 cm) of 24 strands of thread, fold into half and twist over; make 2 strings

a. Fix 24 strands of thread, 23.6 in (60 cm) with tape, then twist

Fix with tape

b. Fold into half and twist toward the other direction (twist over) to make a string

Hold the
string's end

c. Make
a tassel

Roll a double strand of thread around it and tie; push the thread's end inside

Tassel
1.6 in (4 cm)

Approx.
10 in (26 cm)

0.4 in
(1 cm)

Outer fabric
Rear side

Twisted string

Lining
Rear side

❽ Make incisions in the curve at intervals of 0.8 in (2 cm)

❼ Insert the outer fabric into the lining right sides facing, and insert the twisted string, 0.4 in (1 cm), then sew

❾ Turn inside out and overcast the opening to close

Lining's opening
to turn inside out
7.1 in (18 cm)

● Mini Picture Frame

See page 30 for photo and page 38 for Thread Colors Reference Charts.

. .

Materials

Thread

Appleton Crewel Wool

159 Sea green very dark
301 Antique brown very light
303 Antique brown medium
321 Williamsburg blue very light
323 Williamsburg blue medium light
341 Meadow green very light
343 Meadow green medium light
345 Meadow green medium
346 Meadow green dark
347 Meadow green
692 Palomino gold very light
694 Palomino gold medium light
695 Palomino gold medium
696 Palomino gold medium dark
711 Bordeaux very light
713 Antique mauve dark
715 Bordeaux dark
716 Bordeaux very dark

Full-scale embroidery design #1

Use single strand of outline S unless otherwise indicated.

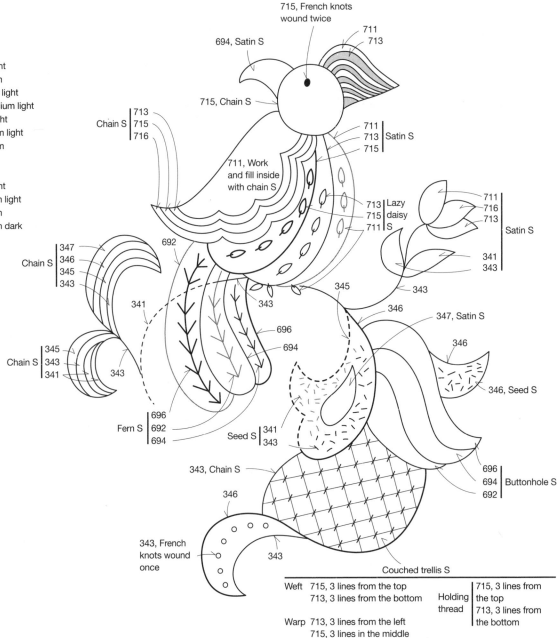

715, French knots wound twice

694, Satin S

711
713

715, Chain S

Chain S { 713 / 715 / 716

711
713 } Satin S
715

711, Work and fill inside with chain S

713 } Lazy
715 } daisy
711 } S

711
716
713 } Satin S

341
343

692

Chain S { 347 / 346 / 345 / 343

341

Chain S { 345 / 343 / 341

343

343

345

346

347, Satin S

346

346, Seed S

696
694

Fern S { 696 / 692 / 694

Seed S { 341 / 343

343, Chain S

346

343, French knots wound once

343

696
694 } Buttonhole S
692

Couched trellis S

Weft 715, 3 lines from the top
713, 3 lines from the bottom

Warp 713, 3 lines from the left
715, 3 lines in the middle
716, 3 lines from the right

Holding thread

715, 3 lines from the top
713, 3 lines from the bottom

68

Full-scale embroidery design #2
Use single strand of outline S unless otherwise indicated.

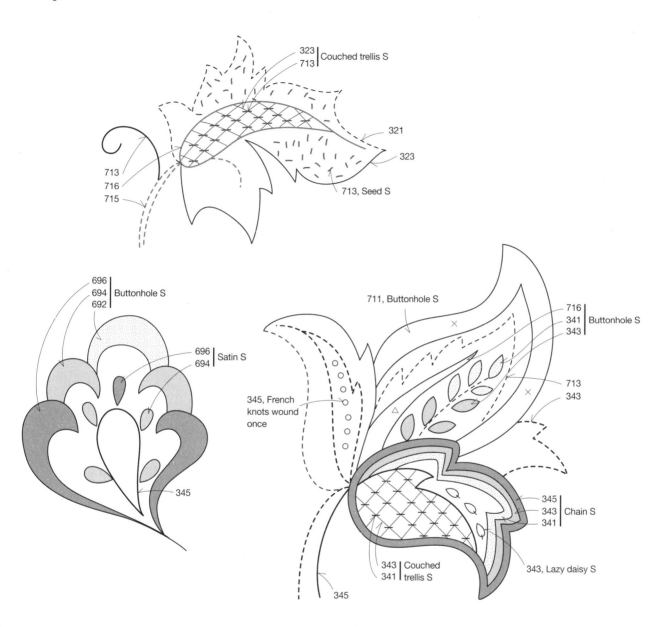

323
713 | Couched trellis S

321

323

713
716
715

713, Seed S

696
694 | Buttonhole S
692

696
694 | Satin S

345

711, Buttonhole S

716
341 | Buttonhole S
343

713
343

345, French
knots wound
once

345
343 | Chain S
341

343, Lazy daisy S

343
341 | Couched
trellis S

345

Full-scale embroidery design #3 (See page 31 for photo.)

Use single strand of outline S unless otherwise indicated.

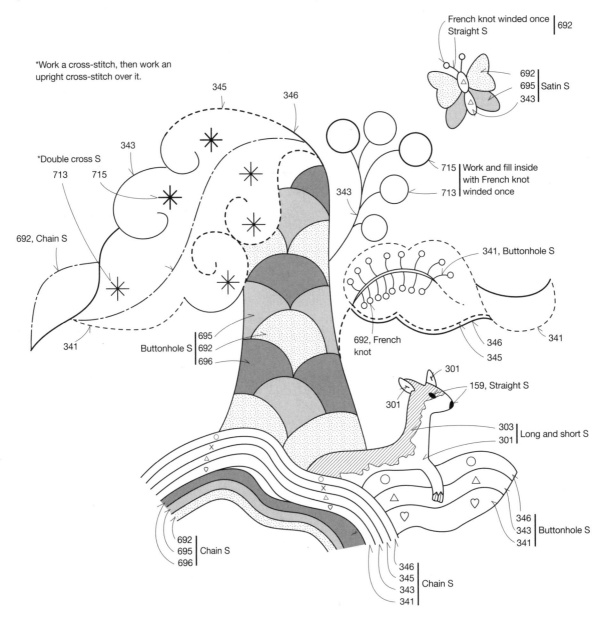

French knot winded once
Straight S | 692

692
695 | Satin S
343

*Work a cross-stitch, then work an
upright cross-stitch over it.

345

346

343

*Double cross S

713 715

692, Chain S

343

715 | Work and fill inside
with French knot
713 | winded once

341, Buttonhole S

341

695
Buttonhole S | 692
696

692, French
knot

346
345

341

301
159, Straight S

301

303 | Long and short S
301

346
343 | Buttonhole S
341

692
695 | Chain S
696

346
345 | Chain S
343
341

● Cushion

See page 28 for photo and page 38 for Thread Colors Reference Charts.

Materials

Fabric

Light brown hemp, 38.6 in x 18.5 in
(98 cm × 47 cm)
Mocha brown wool, 19.3 in x 5.5 in
(49 cm × 14 cm)
Cotton fabric for inner bag, 27.2 in x
19.3 in (69 cm × 49 cm)

Thread

Anchor Tapestry Wool (TW)
8164 Rust orange
8166 Rust orange light
8236 Paprika
8686 Cornflower blue
9100 Apple green medium
9654 Chocolate light

Appleton Crewel Wool (CW)
626 Burnt orange dark
991B White

Anchor #25 Embroidery Thread (AE)
382 Mocha brown
944 Light brown

Other materials

Synthetic fiber cotton ribbon, 4.92 ft x
0.5 in (150 cm x 1.2 cm)

Finished measurements

18.5 in x 12.8 in (47 cm x 32.5 cm)

Sew the hemp and wool fabric together and copy the design and embroider. Finish the work by referring to the diagrams shown on pages 72–73.

Half-scale embroidery design

TW = Tapestry Wool, single strand
CW = Crewel Wool, double strands
AE = Anchor #25 Embroidery, 6 strands

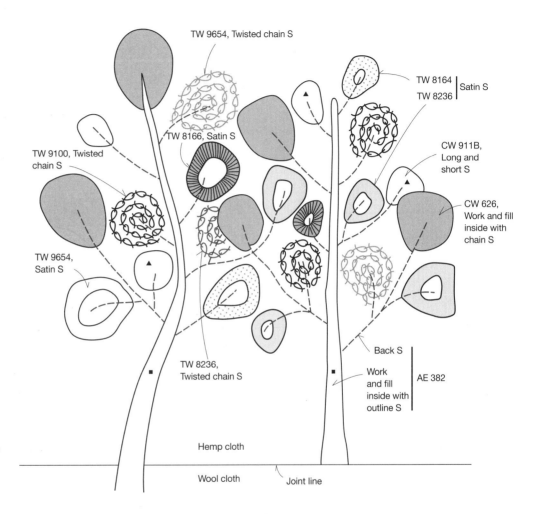

TW 9654, Twisted chain S
TW 8164 | Satin S
TW 8236 |
TW 8166, Satin S
CW 911B, Long and short S
TW 9100, Twisted chain S
CW 626, Work and fill inside with chain S
TW 9654, Satin S
Back S
TW 8236, Twisted chain S
Work and fill inside with outline S | AE 382
Hemp cloth
Wool cloth
Joint line

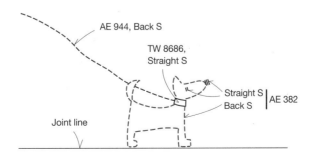

AE 944, Back S
TW 8686, Straight S
Straight S | AE 382
Back S |
Joint line

(continued)

Measurements

● **Front side**

0.4 in (1 cm) all around

11.6 in
(29.5 cm)

10.8 in
(27.5 cm)

1 sheet of hemp cloth

18.5 in
(47 cm)

0.4 in (1 cm) all around

2.8 in
(7 cm)

2 in (5 cm) 1 sheet of wool cloth

19.3 in
(49 cm)

● **Rear side**

10.6 in
(27 cm)

0.4 in
(1 cm)

8 in
(20 cm)

Upper part
1 sheet of hemp cloth

0.4 in
(1 cm)

0.4 in
(1 cm)

18.5 in (47 cm)

2.4 in (6 cm)

7.7 in
(19.5 cm)

2.4 in (6 cm)

5 in
(12.5 cm)

Lower part
1 sheet of hemp cloth

0.4 in
(1 cm)

0.4 in (1 cm)

0.4 in
(1 cm)

0.4 in (1 cm) all around

2.8 in (7 cm)

2 in (5 cm)

19.3 in
(49 cm)

● **Step-by-Step Method**

Front side

Fringe

❷ Embroider

12.8 in
(32.5 cm)

2.4 in
(6 cm)

Hemp cloth

4.3 in
(11 cm)

2 in (5 cm) Wool cloth

18.5 in
(47 cm)

Hemp cloth (Front side)

❶ Sew the hemp and wool cloth, right
sides facing, and open the seam

0.4 in (1 cm)

Wool cloth (Front side)

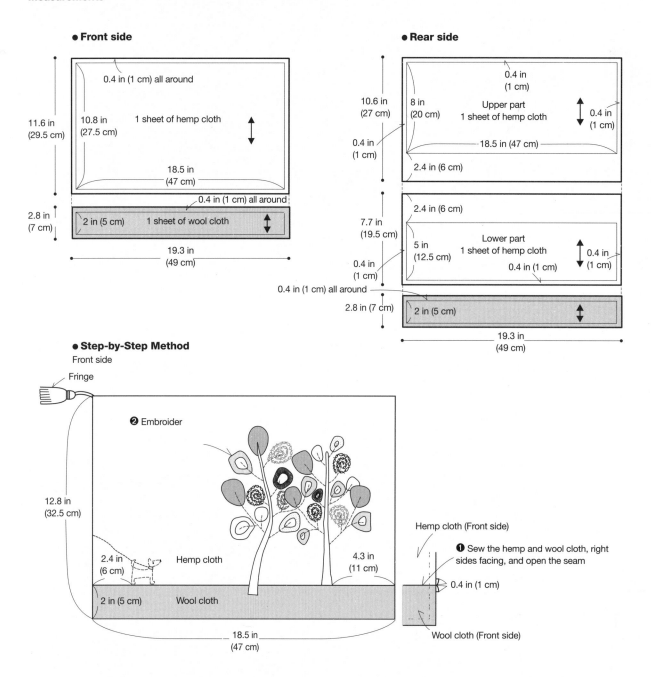

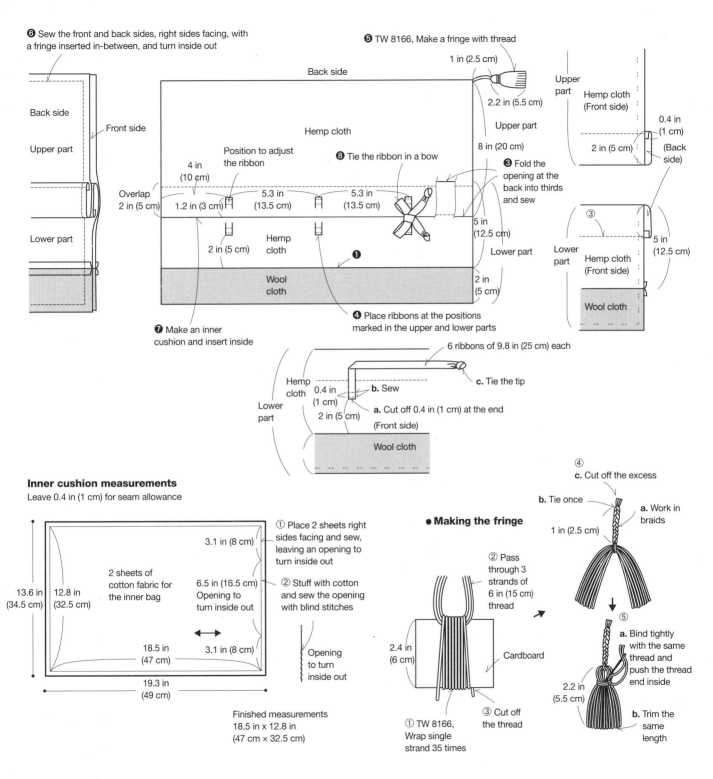

❻ Sew the front and back sides, right sides facing, with a fringe inserted in-between, and turn inside out

❺ TW 8166, Make a fringe with thread

1 in (2.5 cm)

2.2 in (5.5 cm)

Back side

Back side

Front side

Upper part

Upper part

Hemp cloth

Position to adjust the ribbon

❽ Tie the ribbon in a bow

4 in (10 cm)

Overlap 2 in (5 cm)

1.2 in (3 cm)

5.3 in (13.5 cm)

5.3 in (13.5 cm)

Lower part

2 in (5 cm)

Hemp cloth

❶

Wool cloth

Upper part

8 in (20 cm)

❸ Fold the opening at the back into thirds and sew

5 in (12.5 cm)

Lower part

2 in (5 cm)

Upper part

Hemp cloth (Front side)

0.4 in (1 cm) (Back side)

2 in (5 cm)

③

5 in (12.5 cm)

Lower part

Hemp cloth (Front side)

Wool cloth

❼ Make an inner cushion and insert inside

❹ Place ribbons at the positions marked in the upper and lower parts

6 ribbons of 9.8 in (25 cm) each

Hemp cloth

0.4 in (1 cm)

b. Sew

c. Tie the tip

Lower part

2 in (5 cm)

a. Cut off 0.4 in (1 cm) at the end

(Front side)

Wool cloth

④
c. Cut off the excess

b. Tie once

a. Work in braids

1 in (2.5 cm)

● Making the fringe

Inner cushion measurements

Leave 0.4 in (1 cm) for seam allowance

2 sheets of cotton fabric for the inner bag

13.6 in (34.5 cm)

12.8 in (32.5 cm)

3.1 in (8 cm)

6.5 in (16.5 cm) Opening to turn inside out

3.1 in (8 cm)

18.5 in (47 cm)

19.3 in (49 cm)

① Place 2 sheets right sides facing and sew, leaving an opening to turn inside out

② Stuff with cotton and sew the opening with blind stitches

Opening to turn inside out

Finished measurements
18.5 in x 12.8 in
(47 cm × 32.5 cm)

② Pass through 3 strands of 6 in (15 cm) thread

2.4 in (6 cm)

Cardboard

③ Cut off the thread

① TW 8166, Wrap single strand 35 times

⑤

a. Bind tightly with the same thread and push the thread end inside

2.2 in (5.5 cm)

b. Trim the same length

● Scissors Strap

See page 32 for photo and page 38 for Thread Colors Reference Charts.

Materials for 1 strap

Fabric

6 in square (15 cm) unbleached wool
 cloth for cross-stitch; 4 in (10 cm)
 square = 70 x 70 stitches of cloth
2.8 in (7 cm) square unbleached wool
 cloth for lining

Thread

Appleton Crewel Wool

105 Pansy purple dark	401 Forest green light
106 Pansy purple very dark	584 Burnt umbre medium dark
144 Old rose bright	751 Crimson tide very light
145 Old rose medium dark	754 Crimson tide medium light
159 Sea green very dark	841 Hellenic gold very light
183 Bunny brown medium	842 Hellenic gold light
186 Bunny brown dark	844 Hellenic gold bright light
245 Moss green very dark	881 Orchid light
327 Williamsburg blue dark	916 Maple brown
342 Meadow green light	

Other materials

Synthetic fiber cotton ribbon, 11 in x 0.1 in
 (28 cm x 0.3 cm)

Finished measurements

See diagrams on page 76.

Embroider on the outer fabric, then finish as shown by the diagrams on pages 76–77.

Embroidery design and full-scale pattern

See page 76 for Step-by-Step Methods

● A

Use double strands of thread

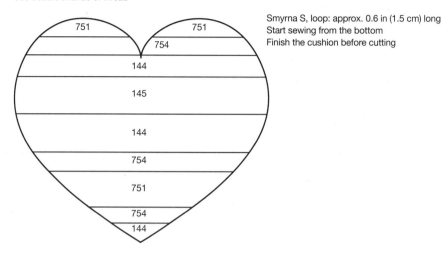

Smyrna S, loop: approx. 0.6 in (1.5 cm) long
Start sewing from the bottom
Finish the cushion before cutting

● B

Use double strands of thread

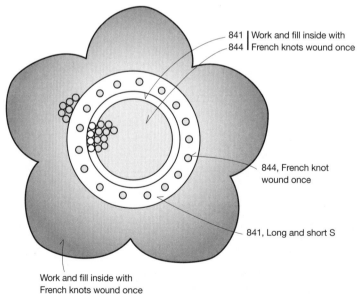

841 | Work and fill inside with
844 | French knots wound once

844, French knot wound once

841, Long and short S

Work and fill inside with French knots wound once

Take double strands of 145, 144, and 144, 754, and arrange them in order so that the threads become darker as you work outward

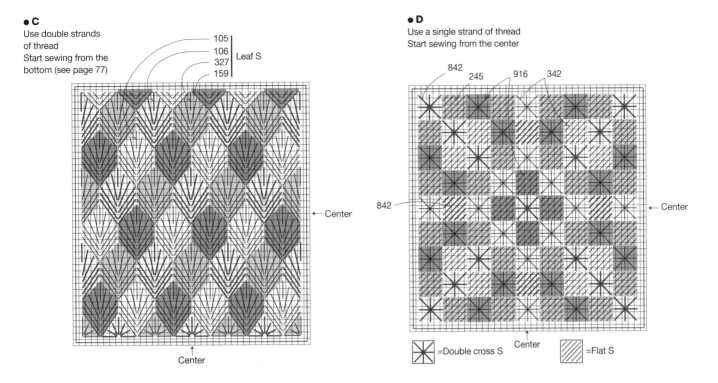

● C

Use double strands of thread
Start sewing from the bottom (see page 77)

105
106
327 | Leaf S
159

← Center

↑ Center

● D

Use a single strand of thread
Start sewing from the center

842 245 916 342

842

← Center

↑ Center

⊞ =Double cross S ▨ =Flat S

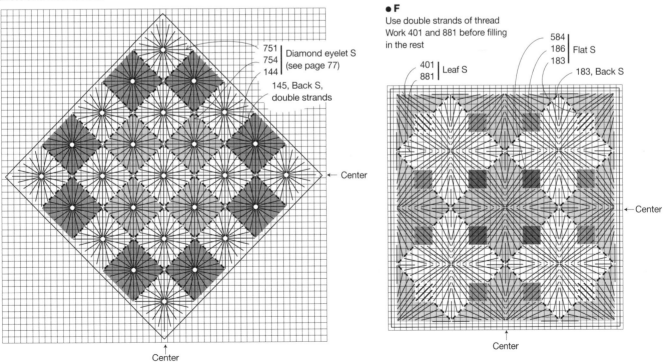

● E

Use a single strand of thread
unless otherwise indicated

751
754 | Diamond eyelet S (see page 77)
144

145, Back S, double strands

← Center

↑ Center

● F

Use double strands of thread
Work 401 and 881 before filling in the rest

401 | Leaf S
881

584
186 | Flat S
183

183, Back S

← Center

↑ Center

Step-by-Step Method

❶ Embroider on the outer fabric, then trim the sides, leaving 0.2 in (0.5 cm) seam. Cut out the lining in the same size as the outer fabric.

Fold the ribbon in half and place it between the fabrics

0.4 in (1 cm)

0.2 in (0.5 cm)

Back side

Fringe

Opening to turn inside out

❷ Put the outer fabric and lining right sides facing with a ribbon and a fringe inserted in-between (a pom-pom for "d"), and sew them while leaving an opening to turn inside out

❸ Turn inside out

Front side

❹ Stuff with cotton and sew the opening with blind stitches

● A

5 in (13 cm)

2.4 in (6 cm)

● B

5 in (13 cm)

2.4 in (6 cm)

● C

5 in (13 cm)

105, 106
Use double strands with Smyrna stitches on the sides

2.2 in (5.5 cm)

0.3 in (0.8 cm)

2.2 in (5.5 cm)

● D

5 in (13 cm)

2.2 in (5.5 cm)

842, Pom-pom (wind 20 times)

0.6 in (1.5 cm)

2.2 in (5.5 cm)

● E/F

5 in (13 cm)

2.2 in (5.5 cm)

2.2 in (5.5 cm)

0.4 in (1 cm)

751 [F 183]
144 [F 881]

1.6 in (4 cm)

Fringe
Wind 40 times (see page 73 for making the fringe)

Making the pom-pom

+ 0.2 in (0.5 cm) diameter

Tie firmly with silk thread or other similar thread of the same color

Pass a string through the knot

Make loops

Finish

Trim and adjust the shape

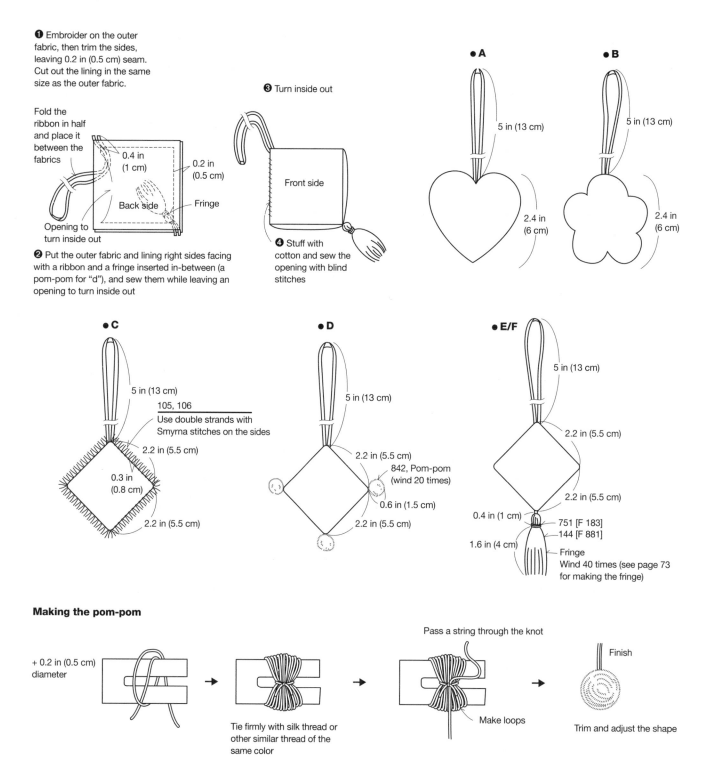

● **Flat Stitch**

● **Double Cross-Stitch**

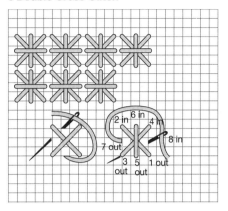

● **Diamond Eyelet Stitch**

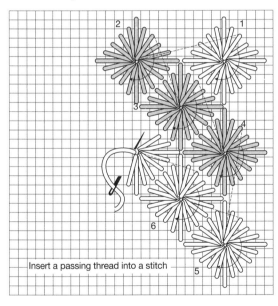

Insert a passing thread into a stitch

● **Leaf Stitch**

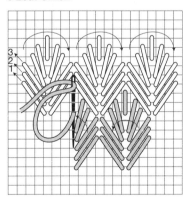

About the Book

Ondorisha Publishers, Ltd, was established in 1945, and has since then published a wide range of books related to handmade hobbies, such as handicraft, knitting, embroidery, cooking, and more. The company's motto has consistently been to allow readers to realize the joy of handmade crafts through simple and comprehensible layouts and text descriptions.

Designers' Credits

Date Book Planner Cover, Accessory Boxes, Bag and Purse, Mini Purse, Stole, Mini Cushion, and *Handbag* by Tae Sasao; *Sewing Kit Case, Clasp Purse, Covered Buttons, Felt Slippers,* and *Holiday Socks* by Noriko Osawa; *Wool Handbag* and *Cushion* by Hisako Nishisu; *Mini Picture Frame* and *Scissors Strap* by Hanako Noda